IMAGES
of America

MOSS BEACH

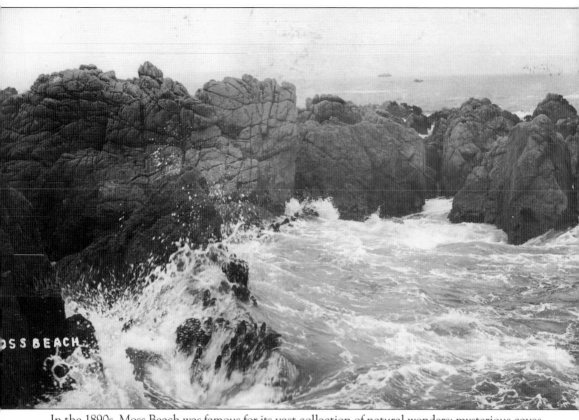

In the 1890s, Moss Beach was famous for its vast collection of natural wonders: mysterious caves, water-spouting rocks, and tide pools teeming with aquatic life—all visible at low tide. As a former rancho, Moss Beach developed its identity as a unique seaside resort, close to San Francisco but secluded enough to feel far, far away. (Courtesy of R. Guy Smith.)

ON THE COVER: When The Reef's was first constructed, it was built on the sand. There was a bathhouse on one side and a dance floor on the other, where an orchestra entertained beachgoers. In horse and buggy, folks drove down a road to the beach, and a chute was used to slide groceries down the cliff to the beach. (Courtesy R. Guy Smith.)

IMAGES
of America

MOSS BEACH

June Morrall

ARCADIA
PUBLISHING

Published by Arcadia Publishing
Charleston SC, Chicago IL, Portsmouth NH, San Francisco CA

Printed in the United States of America

Library of Congress Control Number: 2009941858

For all general information contact Arcadia Publishing at:
Telephone 843-853-2070
Fax 843-853-0044
E-mail sales@arcadiapublishing.com
For customer service and orders:
Toll-Free 1-888-313-2665

Visit us on the Internet at www.arcadiapublishing.com

To Burt Blumert, the love of my life, who passed away in 2009

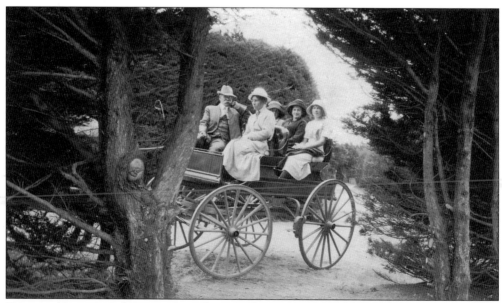

Horse-and-buggy travelers stop for a photograph, on what would become Highway 1 in Moss Beach, in the late 1800s.

CONTENTS

Acknowledgments 6

Introduction 7

1. Mayor Wienke Founds His Fabulous Resort 9

2. The Ocean Shore Railroad Real Estate Promotion Train 25

3. Prohibition Saves the Night 43

4. R. Guy Smith, the Man Who Said He Could Do Anything 59

5. *O Bionda* (Hello, Little Blonde) 73

6. Moss Beach Profile 95

7. Devil's Slide 117

Epilogue 127

ACKNOWLEDGMENTS

Meeting Elaine Martini Teixeira, who grew up in Moss Beach and is a member of a very large, knowledgeable Italian family, led to all kinds of good things that I am able to share with readers in this new book. Elaine's aunt, Lillian Torre Renard, helped fill in the missing blanks of the commercial photographer R. Guy Smith's tenure as postmaster, and her cousin, Sylvia Belli Parker, provided details on the many buildings that have vanished from the landscape.

Local resident Sharon Bertolucci told me stories about exploring The Reef's and meeting old Charlie Nye. And what a pleasure it was to learn the history of famous Dan's Restaurant from the original owner's daughter, Lena Parker, and granddaughter, Donna McClung. Thanks as well to the following: pilot Frank Sylvestri of Western Aviation, who passed away in 2009; Yoshi Sato Mizono, who told me about the life of her older brother, Hamm Sato; Bob and Barbara Senz, cofounders of the annual Dream Machine charity event at the Half Moon Bay Airport; local photographers Deb and Michael Wong of Spring Mountain Gallery; Bob Breen, former Fitzgerald Marine Reserve park naturalist, who gave me essential background material; and Lynne Magee, whose father owned the Flying A Station where mobster Jimmy "the Weasel" Fratianno purchased his gas. Thanks to former abalone diver Tom Monaghan, attorney Connie Phipps, Ashtok Thankur, Model A owner Skip Walsh, Farmer's Daughter owners David Lea and Lynda Santini, Doreen Cvitanovic, Raymond Martini, Coastsider.com's Barry Parr, *Half Moon Bay Review*'s Clay Lambert, Craftsman Bungalow owner Peg Smith, the staff of the 3-Zero Café, writer Sally Richards, and Moss Beach Distillery Restaurant owners John and Kyoko Barbour. A special thanks to Rosina Gianocca, who passed away years ago, but who introduced me to the spectacular R. Guy Smith photograph collection.

INTRODUCTION

One of the best ways to visit Moss Beach is to walk the trail between Pillar Point, a historic, slice-of-cake land stretching into the Pacific Ocean, and the Moss Beach Distillery—the 1920s roadhouse originally called Franks for the colorful Peruvian fellow who built the bar—with its floor that looks like a "bull ring" as a draw for silent film stars, politicians, and adventurous folks who drove to this out-of-the-way place to quench their thirst during Prohibition.

Another "must" to include in the hike is further north, the Fitzgerald Marine Reserve. This provides a good snapshot of the history of Moss Beach, a charming beach town originally conceived by the doomed Ocean Shore Railroad.

A bit more on the geography: Pillar Point is home to what the locals call "the golf ball," because that is what the U.S. Air Force's radar station looks like—a giant white golf ball. It used to be a more conventional flat dish. More than 100 years ago, newspaper editors reported that the U.S. military ascertained that Pillar Point was vulnerable to entry by an enemy navy, one that would land unseen and march north to take over the city of San Francisco.

The area closest to the radar station is, understandably, closed to the public, but there are popular trails nearby. One trail, just south and below Pillar Point, is an easy walk that leads directly to the beach and the home of Mavericks, one of the hottest surfing spots in the world (with waves reaching 70 feet high in the winter). In the distance, Sail Rock can be seen, which is accessible at very low tide.

But there is another tougher, uphill trail that leads north, high above the waves, high above Mavericks. Along this trail, which offers a spectrum of ocean, farmland, and views of the small Half Moon Bay Airport, where the annual Dream Machines event thrills visitors just as the memorable drag races did in the 1950s, wonderful opportunities can be found to stand at the cliff's edge and look at the intimate coves where during Prohibition, when liquor was illegal, whiskey from Canada was landed on the sandy shores below.

It worked like this: "mother ships" from Vancouver waited a couple miles offshore where they were met by fishermen's boats that carried the booze back to shore. There are many coves, and it is not hard to imagine them being isolated. It was an excellent opportunity for locals to pick up good money handling the booty and passing it along to the next source, where it was eventually loaded into an automobile, usually with a cutout trunk to make more room for the often high-grade Scotch whiskey. Ducking Prohibition agents, the booze was rushed to the city, usually on the serpentine San Mateo-Half Moon Bay Road. This curvy road was more reliable than the alternative: the more dangerous, wild and crazy "rumrunner's road." That choice was a twisty, winding, poorly constructed road that traversed the heights of beautiful Montara Mountain, which featured the famous Devil's Slide to the west, the trouble-making geographical barrier that stopped development on the San Mateo County coastside for decades.

Had the Ocean Shore Railroad thrived—an ill-conceived, costly project to its investors as faster trucks and cars turned the idea of riding the train into a dinosaur—life may have turned

out differently for Moss Beach and its collection of natural wonders, including Horseshoe Reef, very visible today at low tide from the cliff trail described above. In the 19th century, there was a vast array of astounding natural wonders, including curious, nameless caves; Spray Rock, which brought giggles from beachgoers when it performed; and huge indigenous granite boulders adorning the gritty sand—a perfect spot for visitors to have their photograph taken with an old-fashioned camera.

Until the Gold Rush in 1849, the coastside had been connected to the vast Spanish mission system, with Moss Beach part of a huge rancho. Wild horses and cattle roamed the fields, and exciting annual festivals were held to show off the special talents of the vaqueros and their use of the riata, or rope. That came to an abrupt end after the United States won the "war" with Mexico (less a war than a series of skirmishes). The coastside ranchos were broken up, and the land passed into the hands of Americans. Out of this emerged the prime real estate eventually known as Moss Beach.

Among the earliest late-19th-century pioneers were the recently arrived German, Jurgen Wienke; his wife, Meta; and their bespectacled daughter, Lizzie, who was bound for San Mateo County politics. The friendly Wienkes founded the Moss Beach Hotel, with its homelike atmosphere, and in the earliest days it could only be reached by stage or horse and carriage. Most famous among the guests was David Starr Jordan, Stanford University's first president. He held a biology degree, and the reefs with their teeming life fascinated him.

To make their hotel profitable, the Wienkes, as well as the lovable Charles Nye who operated The Reef's, a rustic seafood cafe on the sands of the present-day marine reserve, held onto dreams of a railroad bringing carloads of passengers to their doorstep. After the 1906 San Francisco earthquake and fire, many citizens moved out of the city but not to the coastside, which still did not provide good transportation. Even in 1908, when the Ocean Shore Railroad built a pretty station at Moss Beach, it was too late for iron roads because they could not keep up with the rubber tires on trucks and Ford automobiles.

Desperately trying to make ends meet, the Ocean Shore Railroad made arrangements with other businesses to ship produce, such as the coastside's famous but hard-to-figure-out-how-to-eat artichoke, to market in San Francisco. But the artichoke could wilt if left in crates for hours beside the tracks when the train was delayed because, once again, rolling boulders blocked the way at infamous Devil's Slide. It did not take the business-savvy farmers of Moss Beach long to decide that trucks were more dependable.

For a time, the railroad may have carried hundreds of trout to fill the coastside creeks between Pacifica and Purissima, to the north and south of Moss Beach respectively. A San Francisco chemist hired the railroad to carry the estimated 500 tons of seaweed he planned to gather annually from Moss Beach to be used in the production of potash and iodine.

The Wienkes' hotel burned, Nye's The Reef's was wiped out by giant waves, the Ocean Shore Railroad gave up, and only Prohibition saved the economy of Moss Beach. One of the first to take advantage was Billy Grosskurth, who, with his eccentric vaudeville connections, built the Marine View Tavern overlooking today's Fitzgerald Marine Reserve. Frank Torres came next, and only his authentic roadhouse—which was to become the Moss Beach Distillery and a California State Point of Historic Interest—remains, along with a cypress tree-lined street called Wienke Way.

Moss Beach derived its name from the varieties of mosses that flourished in the cracks between the fingers of the prolific reefs.

One

MAYOR WIENKE FOUNDS HIS FABULOUS SEASIDE RESORT

From left to right, Gladys, C. B., and Annie Smith show how much fun it was to fool around at Moss Beach. C. B. sold real estate, and Annie was appointed Moss Beach postmaster until relative Raymond Guy Smith became the head "stamp shooter," a prestigious position he kept for decades. One of the major, early landowners was Jurgen F. Wienke, whose famous Moss Beach Hotel drew guests from all over. (Courtesy of R. Guy Smith.)

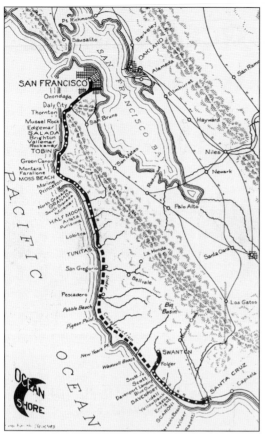

Where is Moss Beach? Follow the "tracks" on the Ocean Shore Railroad map south from San Francisco, and the words Moss Beach jump out in capital letters. After the 1906 San Francisco earthquake and fire, two stations were built at Moss Beach; one serviced Marine View, the area overlooking today's Fitzgerald Marine Reserve. (Courtesy private collector.)

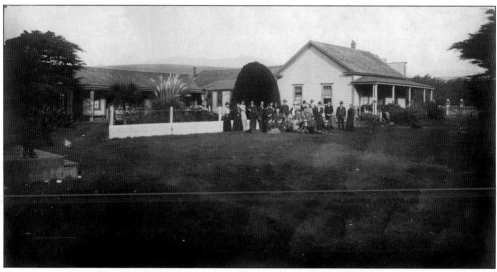

Getting to Jurgen Wienke's Moss Beach Hotel resort was a dusty adventure. Guests traveled by horse and buggy or stage over the serpentine San Mateo-Half Moon Bay Road. Thrill seekers could, perhaps, hire a Native American guide to take them over the crude trail crossing notorious Devil's Slide, which would be the only way to arrive from the direction of San Francisco. (Courtesy of Rosina Gianocca.)

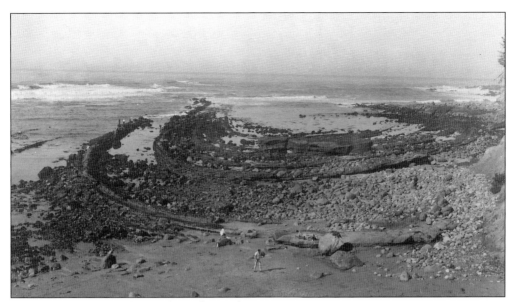

There were a variety of natural wonders and curiosities to be found at Moss Beach, especially in the early 1900s before erosion claimed many of them. And it was natural for people to want to give them names. To many, this reef formation looked just like a horseshoe, and the name stuck. At low tide, Horseshoe Reef is still visible. (Courtesy R. Guy Smith.)

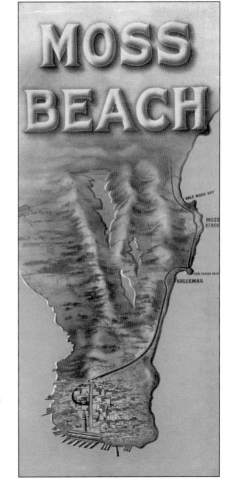

This old Moss Beach pamphlet was used to advertise the resort as a great place to build a home: "It lies directly on the Pacific Ocean safely above high tide, in the arms of an immense cove. Thousands of trees diversify the level area of the vast arena, grouped in shady nooks." (Courtesy R. Guy Smith.)

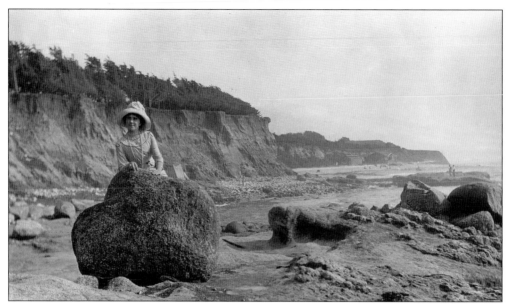

Could the pretty young lady be sitting on the famous natural wonder called Nye's Rock? The big granite boulder was named for Charlie Nye, who owned the most intriguing venue a few steps from the tide pools called The Reef's. It was restaurant without a cement foundation but whose piers were dug deeply into the sand. (Courtesy of R. Guy Smith.)

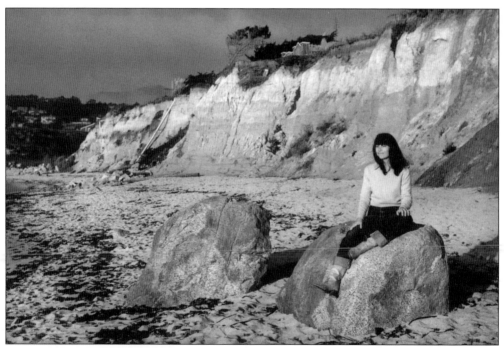

In the 1970s, the author found what she thought was Nye's Rock, worn down by years of erosion but still a fun place to sit and look out at the reefs. According to retired Fitzgerald Marine Reserve biologist Bob Breen, nearby Montara Mountain is made of granite with mica in it, the sole source of granite in the entire County of San Mateo. (Courtesy Suzanne Meek.)

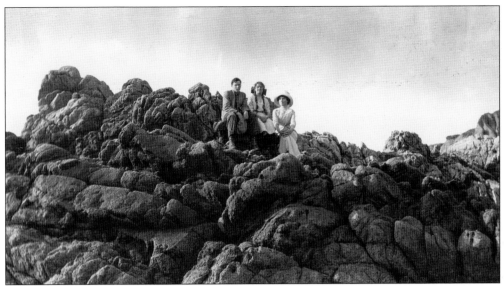

The fascinating rock outcroppings offered creative places to sit and ponder the future possibilities of Moss Beach. There were also many activities in Moss Beach. One could choose either surf or still-water bathing, gondola sculling on a chain of freshwater lakes, or catching abalone, blenny, cabazon, and rockfish. (Courtesy R. Guy Smith.)

Soon after David Starr Jordan took the helm as Stanford University's first president, the academic with a passion for marine biology visited Jurgen Wienke's Moss Beach Hotel. He was there, of course, to roam the beach and walk among the much-discussed seaweed-covered reefs, possibly hoping to catch a glimpse of something exotic. (Courtesy California State Library, Sacramento.)

13

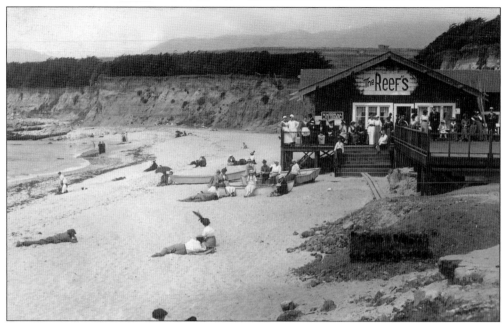

Charlie Nye was a Michigan boy who bought The Reef's, a delight to anyone who encountered the temporary structure on the beach. It hardly seems possible today, but in the early 1900s one could rent a canoe and row between the fragile reefs, then enjoy an abalone lunch at The Reef's. The mollusks were so plentiful, folks could pry them off the nearby rocks. (Courtesy R. Guy Smith.)

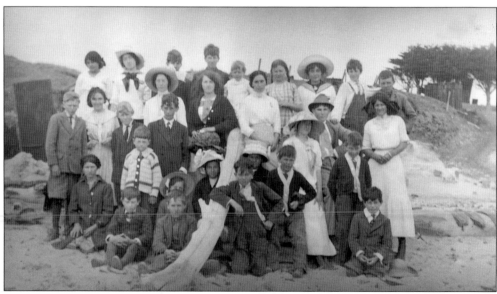

In the 1890s, a ship called the *Argonaut* was wrecked near Moss Beach. It was carrying a load of valuable lumber bound for San Francisco. By now, Junger Wienke was a pillar of the community and everybody called him "the Mayor." He took charge of the shipwreck scene as scores of spectators, many fashionably attired, watched the big waves crash over the ship's bow. (Courtesy R. Guy Smith.)

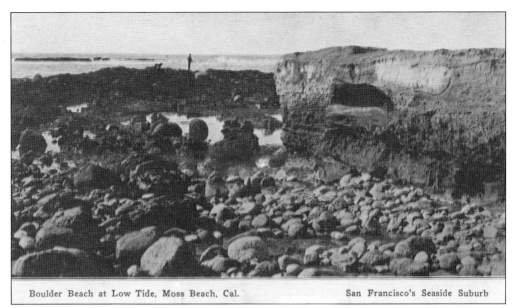

Boulder Beach at Low Tide, Moss Beach, Cal.　　　San Francisco's Seaside Suburb

Among the sights in Moss Beach was Boulder Beach, yet another spot named for its natural wonders. In addition to the beauty of Moss Beach, Mayor Wienke bought his resort because he believed the West Shore Railway was going to build the coastside's first iron road linking San Francisco with Moss Beach and points further south. The plan fizzled, and Wienke had to wait for his scenic railroad. (Courtesy R. Guy Smith.)

This Moss Beach pamphlet reads, "This Is The Right Time To Buy. . . . All of San Francisco is reading signs of promise as it looks Southward; when the whole coast line is just awakening to her possibilities; when one of the most beautifully scenic-routed of Railways is in its inception." At last, the Ocean Shore Railroad was going to be a sure thing. (Courtesy R. Guy Smith.)

Were the folks seen here contemplating the tide pools actually members of a traveling Shakespearean acting troupe? *Coastside Comet* newspaper editor George Dunn's son recalled his father saying the actors often visited Moss Beach. Dunn's *Coastside Comet* office was nearby, and as a reporter he was in a position to know who was in town. (Courtesy R. Guy Smith.)

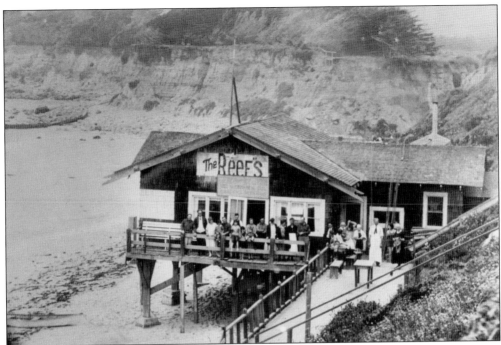

It did not take much to get Charlie Nye, The Reef's friendly owner and cook (pictured here at far right wearing a white apron), to talk about the famous people who dropped in to say hello. The luminaries included author Jack London and horticulturist Luther Burbank. (Courtesy private collector.)

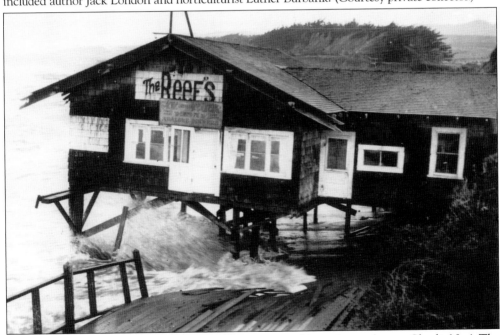

Mayor Wienke and everyone else knew that big waves would one day wash away Charlie Nye's The Reef's. Many a winter storm had worked to undermine and rot out the wooden piers, and one day heavy seas finished the job. Not to be thrown out of business by bad weather, Charlie retreated to the safety of the cliffs above, opening the Reefs II and a hotel. (Courtesy R. Guy Smith.)

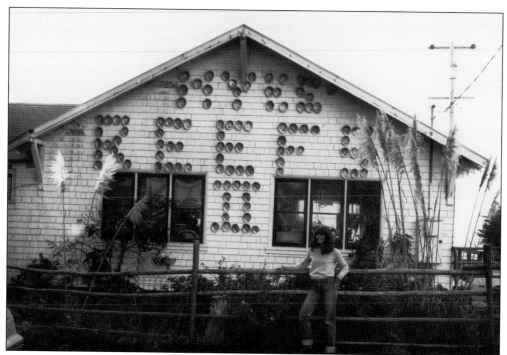

In 1980, the author visited the abalone-studded Reefs II at the corner of Nevada Street and Ocean Boulevard. The address may be an intriguing coincidence because of Nye's distant political connection with silver millionaire Nevada senator John P. Jones, who also lived at Nevada and Ocean, but at Villa Miramar in Santa Monica, a town he cofounded. (Courtesy Suzanne Meek.)

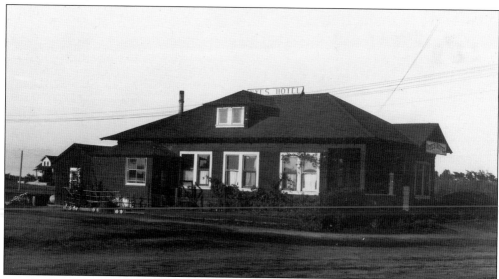

Charlie Nye owned a good chunk of land marked by Beach and Nevada Streets. The address remains mysterious: Nevada senator James Nye was succeeded by silver millionaire John P. Jones, who made millions in the silver mines. He retired to Villa Miramar at Nevada Street and Ocean Boulevard in Santa Monica. Is it a coincidence that Charlie Nye set up shop at Nevada Street and Ocean Boulevard in Moss Beach? (Courtesy R. Guy Smith.)

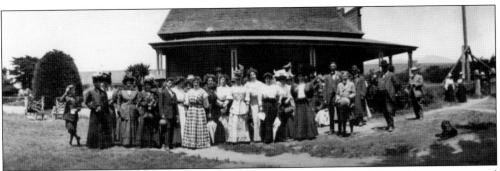

The Wienkes—Jurgen, wife Meta, and daughter Lizzie—thrived at their hotel but were strapped financially because the scenic railroad did not arrive until after the 1906 San Francisco earthquake. Lizzie became a popular schoolteacher and married the county clerk. When he suddenly died, she filled his position and became an item when she wed the powerful county surveyor. (Courtesy R. Guy Smith.)

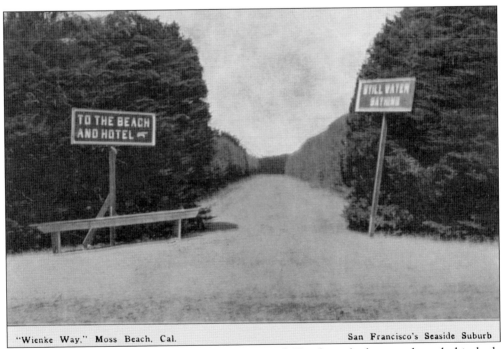

"Wienke Way," Moss Beach, Cal. San Francisco's Seaside Suburb

To sign the guest register at Mayor Wienke's Moss Beach Hotel, one had to pass through this shady lane. Remember, Wienke planted all the cypress trees, and today some of the original ones still thrive. Wienke Way is all that remains of the Wienke legacy, the family who founded their famous 19th-century resort among the natural wonders of Moss Beach. (Courtesy R. Guy Smith.)

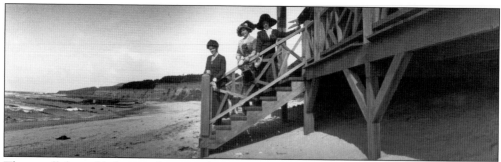

These well-dressed ladies are about to take a stroll on the beach near the famous tide pools at the northern end of Moss Beach. In the 1920s, the well-known San Francisco Academy of Science marine biologist Olga Hartmann could be seen studying and collecting marine curiosities, including samples of rock-boring clams and the extremely rare small mollusks called chitons. (Courtesy R. Guy Smith.)

S. F. Light

The late Professor S. F. Light (1886-1947) was for twenty-two years a member of the Department of Zoölogy at the University of California, Berkeley. His active interests ranged widely over the field of the invertebrates, and ran the gamut from taxonomy (alcyonarians, scyphozoans, termites, copepods) to the social physiology of termites, their protozoans, symbionts, and caste determination.

Dr. Light gave an extraordinary amount of time and careful thought to his teaching at all levels and exercised a peculiarly pervasive and long-lasting influence on his students' points of view, interests, and habits of thought. His advanced courses were marked by a critical, appreciative, phylogenetic morphology and a critical natural history which insisted on a full realization of the values of sound systematics, keen field observation, and concrete, testable interpretations. The essence of his natural history course was to be found between the lines of its syllabus, which combined a dynamic approach to basic principles (not only of invertebrate zoölogy but of field biology and scientific methodology) with practical aids to the mastery of a specific fauna. It was the result of more than ten years of active contact, virtually the year around, with that fauna and of continual efforts to perfect a teaching approach which aimed at very high and exacting goals. In the present manual, a conscientious updating of the original published syllabus, the revisers have, I believe, been successful in their aim of retaining the values of Light's approach.

Professor Light played his role in biology and academic life in personal contacts rather than in national or university affairs, and profoundly affected the attitudes of many graduate students and associates. Those who knew him will remember the personal characteristics of modesty—extending to a real underestimation of self—, of appreciation of disciplines which lay beyond his own field of study, of exacting criticism in the use of words and ideas— driving him now to caution, now to very forward positions—, of sincere interest in the human relations of his students and assistants, and of a highly developed aesthetic

Longtime Fitzgerald Marine Reserve Park naturalist Bob Breen (now retired) says following the 1906 San Francisco earthquake and fire marine biologists came to study the aquatic life in the tide pools. University of California, Berkeley, zoology professor S. F. Light wrote the book *Intertidal Invertebrates of the Central California Coast*. Still used in schools, the second edition has a photograph of Nye's Rock. (Courtesy private collector.)

Retired park naturalist Bob Breen remembers meeting Charlie Nye in 1971. By then, the former The Reef's owner was blind. But Nye welcomed marine biology students from the University of California, Berkeley, to the Reefs II, where they slept on the floor and spent the daylight hours studying the tide pools. The "things" they collected were dissected on Nye's tables. (Courtesy Deb Wong.)

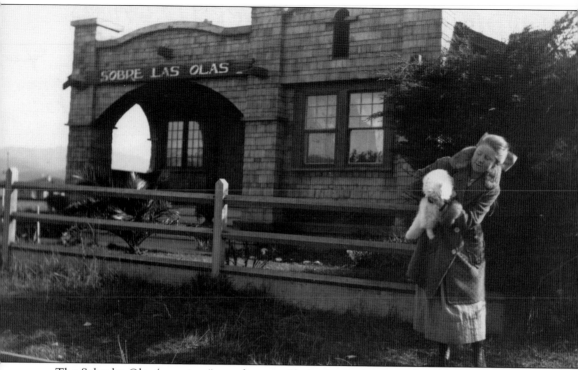

The *Sobre las Olas* (meaning "over the waves") sign greeted guests who stayed at Charlie Nye's hotel. Later the building served as the family home, across the way from the abalone-covered Reefs II. Nye hosted abalone chowder parties there, at the corner of Nevada Street and Ocean Boulevard. (Courtesy R. Guy Smith.)

The author visited Charlie Nye Jr. from time to time at the Reefs II in the late 1970s. His father was no longer living and there were no more abalone chowder parties or visits from the marine biology students, but Charlie Nye Jr. was the kind of friendly host impossible to forget—a reminder of another time and place. (Courtesy private collector.)

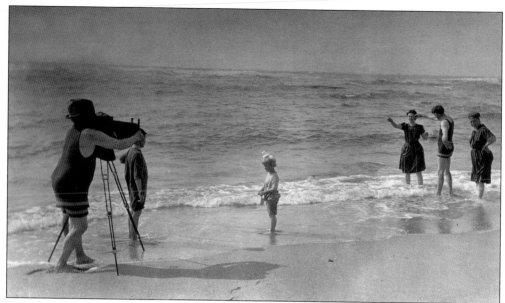

A visit to Moss Beach was not complete without having a photograph taken on the beach, on a giant granite boulder, in front of a cave, or next to one of the resort's natural wonders. There are more images of Moss Beach than any other Ocean Shore Railroad stop.

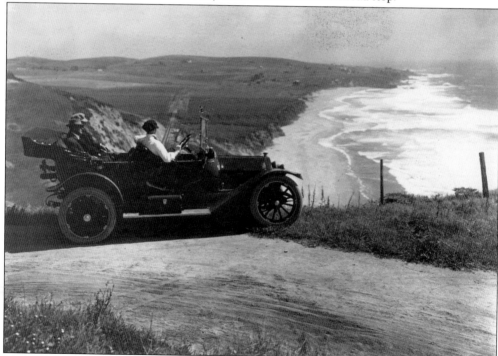

In 1914, three writers and a photographer from *Motoring* magazine hopped into a new convertible Kissel Kar. They were writing an article about the beautiful scenery and the condition of the roads. What disappointed them most was Pedro Mountain Road from the north, which was a twisty, steeply graded road they could not recommend to the average driver. There was even a sign that warned automobilists away. (Courtesy of California State Library.)

Two

THE OCEAN SHORE RAILROAD REAL ESTATE PROMOTIONAL TRAIN

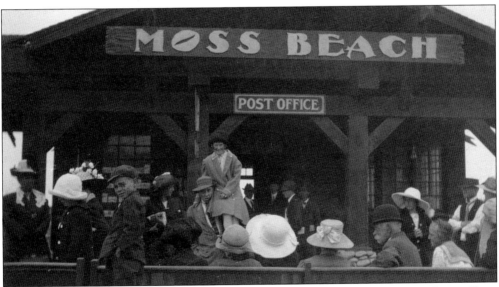

After years of waiting for "rapid" transportation from Moss Beach to San Francisco, Ocean Shore Railroad engineers dynamited their way through geographical barriers near Devil's Slide, rolling out a scenic iron road to the delight of everyone. It was called "the cool scenic route," and no wonder as the rails were embedded into the edge of the cliffs a couple of hundred feet above the crashing surf. Passengers arrived at one of two train stations and were immediately met by real estate men anxious to tell them all about the natural wonders of Moss Beach. Observers called the Ocean Shore a "real estate promotion railroad" whose purpose it was to bring potential lot buyers directly to the property for sale. Originally the Ocean Shore Railroad was to link San Francisco with Santa Cruz, a distance of about 96 miles, but the rails never reached farther than Tunitas Creek, south of Half Moon Bay. (Courtesy R. Guy Smith.)

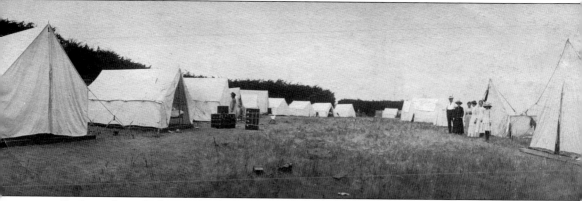

Frightened people fleeing the devastation of the 1906 San Francisco earthquake and fire found relief in Moss Beach, where a temporary "tent city" had been established. Simultaneously, Jurgen Wienke, also known as "the Mayor," offered his land for purchase. It was believed that property would be an "easy sell" to these jittery folks seeking safety. (Courtesy R. Guy Smith.)

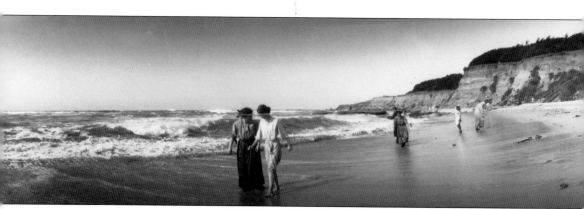

A brochure about Moss Beach asked readers, "In this Strenuous Age and with our Newly-Made History, what City has a more Inalienable Right to 'Nerves' than has San Francisco? Where is the Rest Cure for San Franciscans? They will learn with ever increasing pleasure the answer—In One Ideal Spot: Moss Beach." (Courtesy R. Guy Smith.)

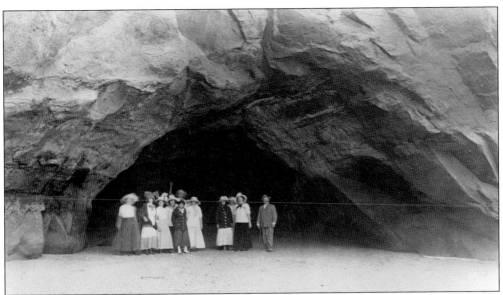

According to a Moss Beach pamphlet, "Submarine Beds of Granite" formed a "Veritable Playground" steps away from this joyful group posing in front of a mysterious cave. More poetically, "When waves wont to play at hide and seek along the crag-lined shore, go out to join the greater billows in the unfathomable deep." (Courtesy R. Guy Smith.)

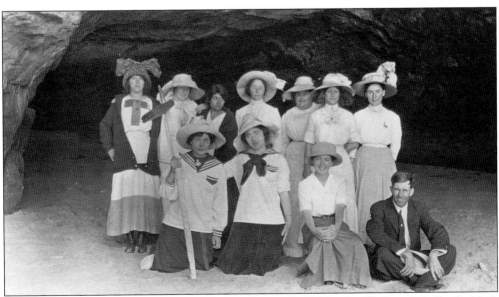

Tide poolers, overnight guests at Mayor Wienke's Moss Beach Hotel, and visitors to Charlie Nye's The Reef's stopped to pose in front of the seaside resort's famous cave. People in this group are wearing the most fashionable clothing of the times. (Courtesy R. Guy Smith.)

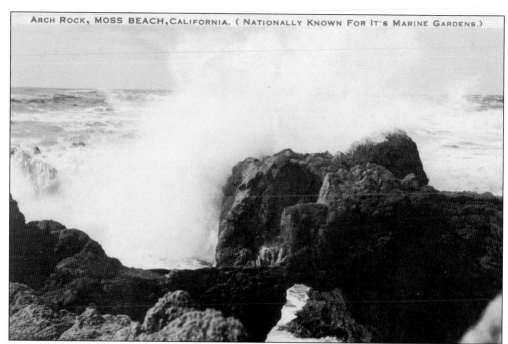

The postcard showcases Arch Rock, one of the natural wonders of Moss Beach's marine gardens. From a brochure was the following, "Where the rare sea rose springing from her moss bed, vying with the many tinted shell, tremblingly enfolds, as the protecting waters glide seaward, that mysterious germ of animal life so minute, so mysterious, and again unfolding in new beauty at the kiss of the returning wave." (Courtesy R. Guy Smith.)

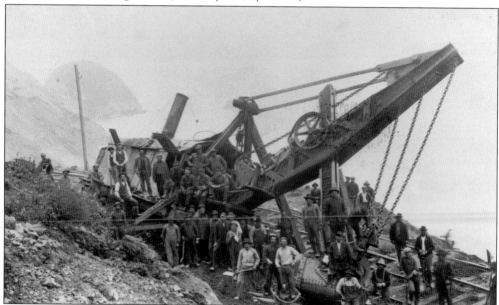

It was a foggy day when this crew of Ocean Shore Railroad construction workers posed on a complicated-looking piece of earthmoving equipment. These rugged men look like they are standing near the challenging geographical barrier known as Devil's Slide. Behind them, a section of the new iron road is visible, laid down high above the crashing waves. (Courtesy private collector.)

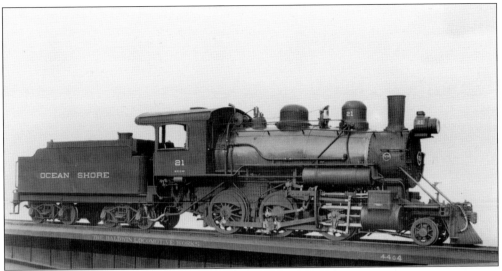

There is no date on this builder's photograph of Ocean Shore Railroad locomotive LS 21 2-6-0 type, Baldwin Works, Class 8-36-D, 51. The Ocean Shore Railroad purchased used equipment from Southern Pacific, which was running a very successful railroad line on the peninsula on the opposite side of the mountainous barriers. (Courtesy private collector.)

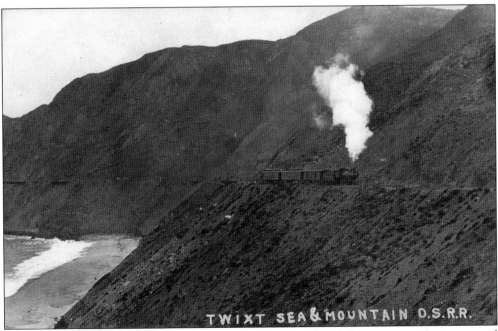

The Ocean Shore Railroad's iron road cut an exciting visual path for passengers "twixt sea and mountain." When most people think of the railroad, they may not realize that the locomotive emitted a great plume of smoke as it delivered passengers and potential home buyers to the Moss Beach and Marine View Stations. (Courtesy private collector.)

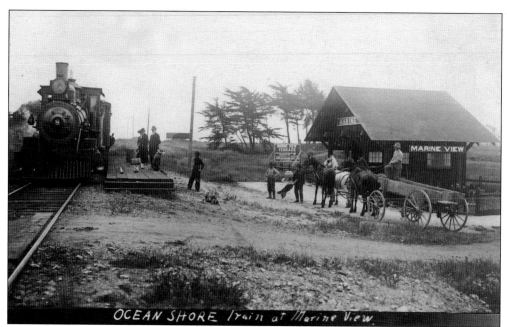

Few people know that originally there were two Ocean Shore Railroad stations in Moss Beach. This one served passengers headed for Marine View, where today the Prohibition roadhouse Moss Beach Distillery Restaurant is located. Back about 1912, the Marine View Tavern stood in the distillery's parking lot. (Courtesy private collector.)

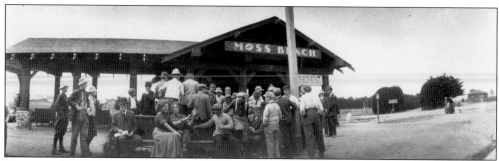

Passengers headed for Moss Beach usually stepped off the platform at this pretty station, where many photographs were taken. According to Ocean Shore Railroad financial documents, while the stations exuded a certain charm, they were not expensive to build and were in keeping with the idea that the railroad was linked to the promotion of real estate. (Courtesy R. Guy Smith.)

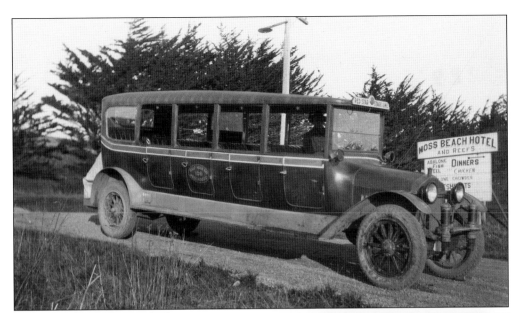

The big Red Star Stage, which resembled the more modern taxicab, met passengers who arrived at the Ocean Shore Railroad's Moss Beach Station. Guests were then escorted to Wienke's famous hotel, taking the route down the cypress-lined lane, today called Wienke Way, west of Highway 1. (Courtesy R. Guy Smith.)

Coastside Transportation Company driver George McCormick drove San Francisco guests bound for the Moss Beach Hotel and marine gardens to their destinations. A typical postcard of the time praised the seaside community with these words, "People looking for a pleasant place to spend their outing this summer can find no better place in California than Moss Beach." (Courtesy Marian Miramontes.)

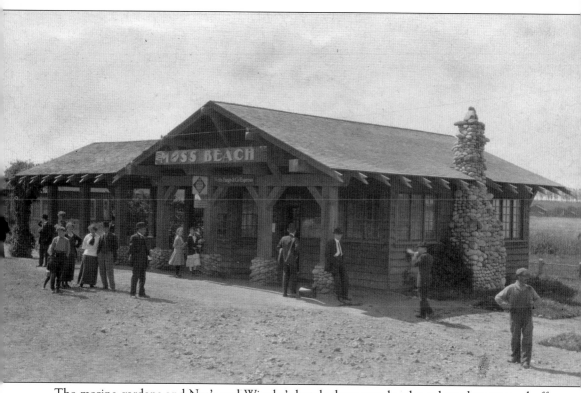

The marine gardens and Nye's and Wienke's hotels drew people who, when they stepped off the train, were exposed to sales pitches from zealous real estate men. The Moss Beach Railroad Station was a popular place to meet friends; in the early years, it was also home to the post office where postcard photographs of the stations were available for purchase. One such postcard read, "If you will meet me at Moss Beach, the most picturesque beach on the Pacific, only 22 miles from San Francisco on the new Ocean Shore double track electric railway, you will become even more interested when you see the property." When the vacation or day trip ended, the railroad station was the center of activity, with clusters of people sitting on the benches and chatting as they waited for the train to take them north across Devil's Slide and back home to San Francisco. (Courtesy R. Guy Smith.)

As a promotional real estate railroad, the Ocean Shore had its own newspaper called the *Coastside Comet.* Founder George Dunn named it after Haley's Comet because its orbit was the talk of 1910. The *Coastside Comet*'s office still stands on Highway 1. George Dunn smoked 15 cigars a day and was the prime force behind construction of the Pillar Point breakwater and Highway 1. (Courtesy R. Guy Smith.)

The tradition of the local press is carried on today. Coastsider. com's Barry Parr (left) and *Half Moon Bay Review* and *Pescadero Pebble* editor Clay Lambert pose in front of the building that originally housed the *Coastside Comet.* George Dunn, the *Comet*'s editor, bought the *Half Moon Bay Review* in 1921. (Courtesy Deb Wong.)

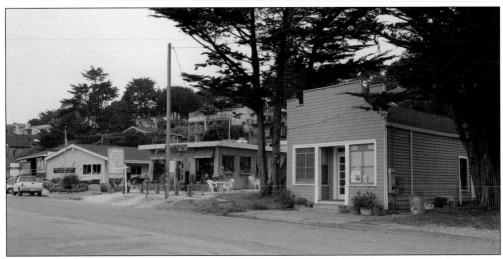

This building was home to the *Coastside Comet*, the post office, the telephone switchboard, the electric company, and a real estate office. Not many old buildings on the coastside have survived, but this one has lived to see the passage of many decades. (Courtesy Deb Wong.)

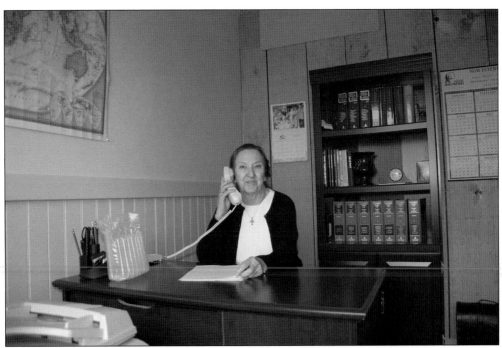

Coastside attorney Connie Phipps takes a call in the building that housed the *Coastside Comet*. But it is better known as the post office where Raymond Guy Smith reigned as the chief "stamp shooter" for decades. The first old-fashioned telephone switchboard was installed here, and John Kyne, father of author Peter Kyne, made the first long-distance phone call to his son, who was out of town. (Courtesy Deb Wong.)

Early Moss Beach was a small place; everybody knew everybody else, and everybody knew Peter B. Kyne was going to write himself into literary history. His father, John, was a Moss Beach farmer, and his mother, Margaret, taught school while Peter wrote about the characters he met in Half Moon Bay. Kyne rose to international fame, and his books were translated into 26 languages. (Courtesy private collector.)

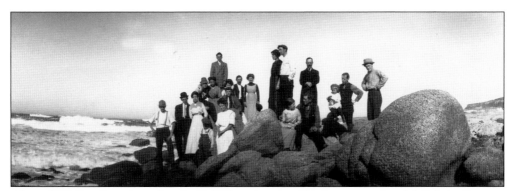

About 1912, San Francisco chemist H. Wilson began collecting seaweed and drift kelp. Because it was in the ocean, the kelp contained large amounts of iodine and potash, which could be transformed into an antiseptic used in medicine to treat wounds and sores in the early 20th century. Wilson planned to gather 500 tons of seaweed annually. (Courtesy R. Guy Smith.)

The coming of the Ocean Shore Railroad had been delayed, then almost financially ruined, by the 1906 San Francisco earthquake. For a time, the company recovered, downsized, and got its house in order, and 1912 was a very good year as hotels and schools were built on the coastside. This charming Moss Beach home was one of those constructed during that short-lived heady time. (Courtesy R. Guy Smith.)

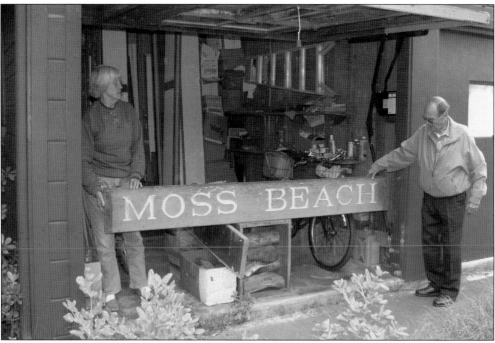

Coastside residents Burt Blumert, the author's longtime companion who passed away in March 2009, and Peg Smith stand in front of Peg's 1908 craftsman bungalow home. Peg and Burt are holding up what appears to be the railroad station's "Moss Beach" sign, which Peg found stashed in the garage when she bought the old house. (Courtesy Deb Wong.)

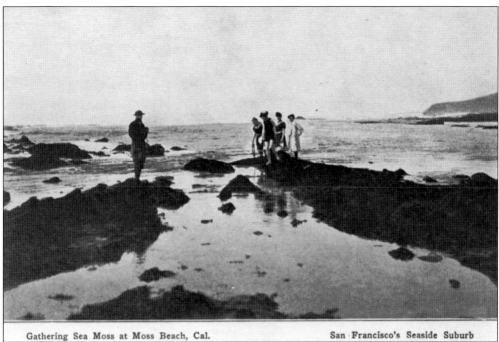

Gathering Sea Moss at Moss Beach, Cal.　　　　San Francisco's Seaside Suburb

The ocean bathers standing on the reefs are gathering moss. At one time, moss was all the rage, picked for decorative display in gardens. Sadly, the special specimens so carefully collected and catalogued by Academy of Sciences marine biologists were lost forever after the 1906 San Francisco earthquake. (Courtesy R. Guy Smith.)

In the 1970s, it was hard for the author to resist the temptation of wearing ribbons of kelp, or large pieces of seaweed. In the 1930s, marine biologist S. F. Light often visited the unique beach, leading to the publication of his book *Intertidal Invertebrates of the Central California Coast*. (Courtesy private collector.)

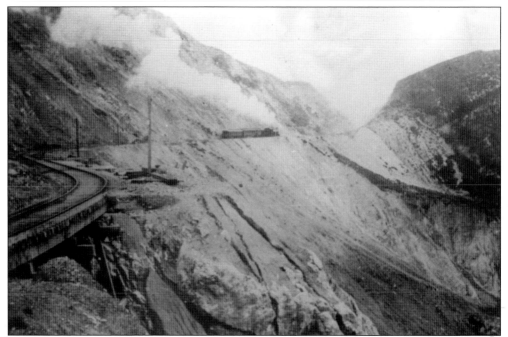

With the new, freedom-giving automobile poised to take a big share of the railroad's revenue, forever changing the habits of travelers, the Ocean Shore Railroad puff-puffed to keep up its image as the most imaginative way to visit Moss Beach. Meanwhile, crossing Devil's Slide stymied progress as loosened rocks continued to tumble onto the tracks, throwing a wrench into the Ocean Shore's schedule. (Courtesy private collector.)

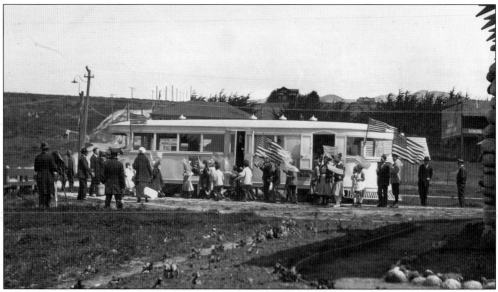

It was becoming obvious that good roads for automobiles, not railroads, were the future. This did not bode well for the Ocean Shore Railroad, a real estate promotion train. Fewer passengers bought tickets, so the railroad people courted the farmers—even shipping trout to be deposited into coastside streams. To slash costs, this little gas train was put into operation. (Courtesy R. Guy Smith.)

If proof was needed that shutterbug and postmaster R. Guy Smith took most of the photographs of the two train stations at Moss Beach, here it is. This letter signed by railroad general agent I. N. Randall thanks Guy Smith for taking pictures of the Ocean Shore's new little gas car. (Courtesy private collector.)

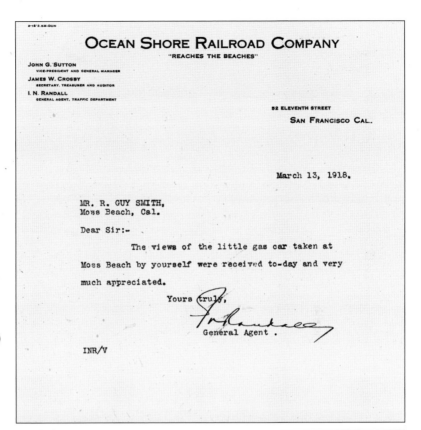

OCEAN SHORE RAILROAD COMPANY

"REACHES THE BEACHES"

JOHN G. SUTTON
VICE-PRESIDENT AND GENERAL MANAGER
JAMES W. CROSBY
SECRETARY, TREASURER AND AUDITOR
I. N. RANDALL
GENERAL AGENT, TRAFFIC DEPARTMENT

52 ELEVENTH STREET
SAN FRANCISCO CAL.,

March 13, 1918.

MR. R. GUY SMITH,
Moss Beach, Cal.

Dear Sir:-

The views of the little gas car taken at Moss Beach by yourself were received to-day and very much appreciated.

Yours truly,

General Agent .

INR/V

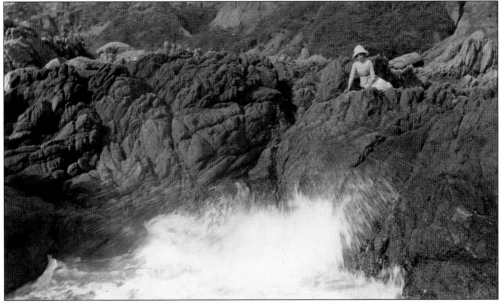

As dreams of dominating transportation between San Francisco and Moss Beach slipped away, so did the image of Moss Beach as a resort, even with its many natural wonders. Travelers loved the freedom the automobile gave them, plus they could cover many more miles than the railroad. (Courtesy R. Guy Smith.)

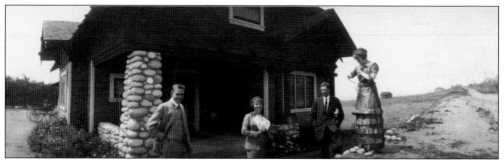

In the 1900s, real estate men came to Moss Beach to build houses and publicize the seaside suburb. C. B. Smith hired his talented nephew R. Guy Smith ("I can do anything") to take photographs of everything Moss Beach. Guy's images were so original that many are of archival quality. And the homes from that era still stand on the older west side of Moss Beach. (Courtesy R. Guy Smith.)

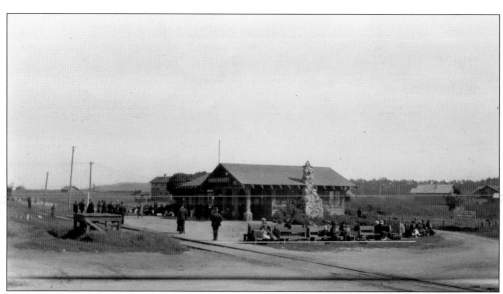

Note the "Moss Beach" sign on the Ocean Shore Railroad station. Is this the same sign that Peg Smith and Burt Blumert are holding up in the photograph a few pages back? After the Ocean Shore Railroad called it quits at the beginning of Prohibition, the station stopped serving passengers. (Courtesy R. Guy Smith.)

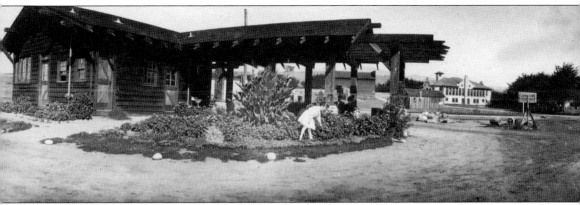

In the early 1900s, the coastside was going to be the new "Coney Island of the West," and everyone was excited about the railroad's "cool scenic route." The new community of Moss Beach was coming to life. Prospective lot buyers were invited to visit the coastside on the weekends. They were offered a free ride and a free lunch followed by a pitch from salesmen who worked feverishly to sell building lots. The folks were told that once the railroad was linked with Santa Cruz, they would have wonderful rapid transit into the heart of San Francisco. Few of the Ocean Shore Railroad's stations survive today. The Marine View Station vanished from the landscape. Some time after the railroad stopped servicing the coastside, the Moss Beach Station, the scene of so many charming photographs, was turned into a broom factory. (Courtesy R. Guy Smith.)

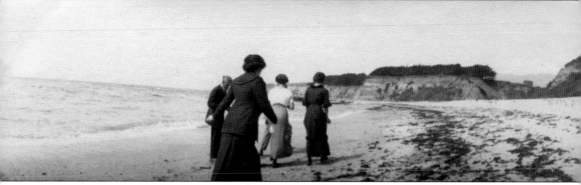

Jurgen Wienke's Moss Beach Hotel burned in the late 1900s. It is not known how the loss affected him, but to run a successful, profitable beach resort, he needed a dependable way to get his guests to Moss Beach, and the Ocean Shore Railroad was not living up to its promise. Wienke also owned acres of property, and the lots he subdivided were not selling either. Seems that the predictions of folks fleeing San Francisco after the 1906 earthquake and fire for the safety of Moss Beach were not coming true. Home construction was taking place on the peninsula, where the land was flat and Southern Pacific Railroad service dependable. By 1910, when the *Coastside Comet* newspaper was founded, many people were fascinated with the automobile. The freedom of a vehicle with rubber tires carried them deeper into the countryside. The dream of the Ocean Shore Railroad real estate promotion train faded away. (Courtesy R. Guy Smith.)

Three

PROHIBITION
SAVES THE NIGHT

Frank Torres "led a life of romance and adventure which makes the lives of us ordinary stay-at-homes quite pale beside it," according to author Ruth Thompson. Born in Peru, Frank left home at 14 and traveled the globe, trekking through Central and South America, Europe, and the Philippines. As a steward on vessels that called at ports of the world, he "learned to cook in every language." He also rubbed elbows with the rich and famous, including Alice Roosevelt, a cousin of future first lady Eleanor Roosevelt. About 1920, Frank Torres came to Moss Beach where, at first, he had an "attractive rambling old place," but in 1928 he built his new "bungalow restaurant" overlooking the nationally known marine gardens. Members of the Torres family helped prepare meals in the kitchen where Frank Jr. was the chef. Frank's wife, Fanny Lea Torres, could often be found bartending while Victor worked as a waiter and played the piano. (Courtesy R. Guy Smith.)

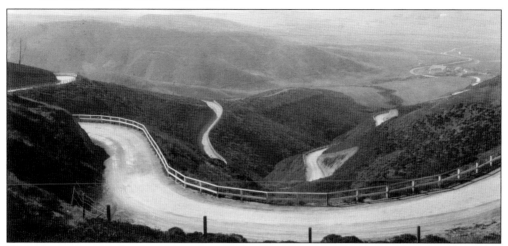

With the real estate development train off the map, the only way to get to Moss Beach from the north was via the slinky, steeply graded Pedro Mountain Road. Once again, isolation kept many folks away. However, the seclusion paid off handsomely for the Prohibition-era bootleggers and rumrunners whose work was best done when not under the microscope. (Courtesy R. Guy Smith.)

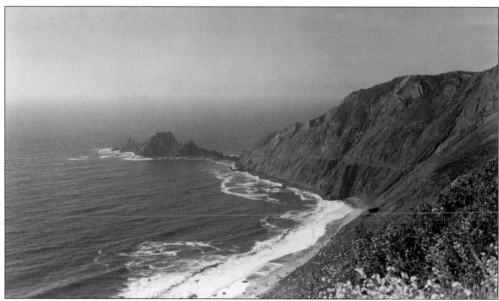

Looking closely at the cliff in this photograph, one can see that the footprint of the Ocean Shore Railroad's old iron road is visible. It was a thrilling ride for the passengers; just as exciting as a ride across the old Pedro Mountain Road must have been for automobilists. Both routes led to Moss Beach and remain visible today, but one can only hike Pedro Mountain Road. (Courtesy R. Guy Smith.)

In 1914, when the writers from *Motoring* magazine visited Moss Beach, they were driving a new convertible Kissel Kar. Their published descriptions of twisty Pedro Mountain Road were devastating. In fact, they discouraged drivers from using the road with more sharp turns than a person could count. In places, the pavement suddenly dropped a foot or more, so one can imagine the damage to rubber tires. (Courtesy R. Guy Smith.)

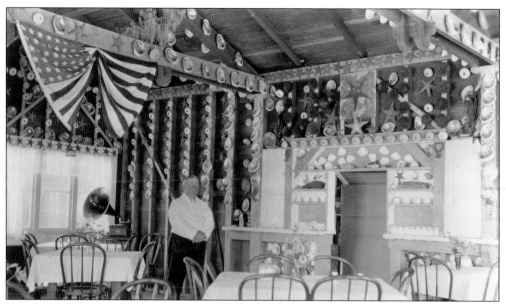

Was Charlie Nye a player during Prohibition? Was booze unloaded on the beach outside his front door? It is a toss up. Charlie and his son, also called Charlie, said, no, they kept to themselves during that heady time. But some locals say, yes, Nye was involved to the extent that he cooperated with the bootleggers. And he did not stop cooking his delicious abalone dinners. (Courtesy R. Guy Smith.)

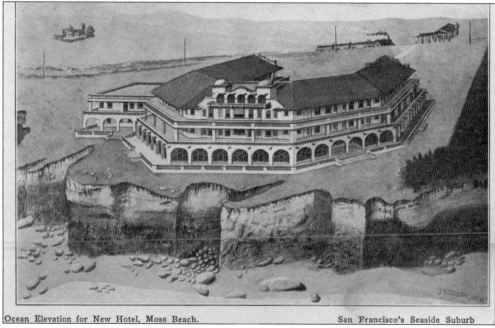

Ocean Elevation for New Hotel, Moss Beach. San Francisco's Seaside Suburb

Here is an illustration of an elaborate, proposed hotel overlooking the cliffs of Moss Beach. If built as shown, the ragged cliff would not have supported the heavy building. However, not far from this cliff a hotel was built, this one called the Marine View Tavern. It was located in what is now the parking lot of the Moss Beach Distillery, the Prohibition roadhouse that still stands. (Courtesy private collector.)

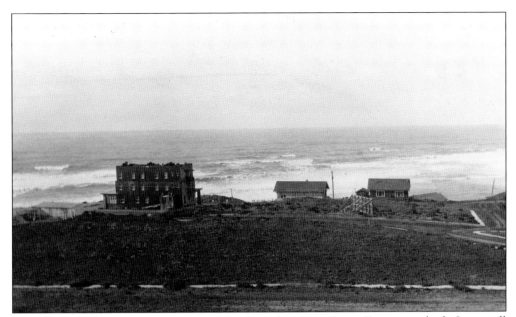

The Marine View section of Moss Beach is where the Marine View Tavern was built. It was tall with many windows and a spectacular ocean view of the whitecaps. The Marine View Tavern stood in between The Reef's and the Moss Beach Hotel. Billy Grosskurth ran the tavern—his professional background was in vaudeville and circus animals. (Courtesy R. Guy Smith.)

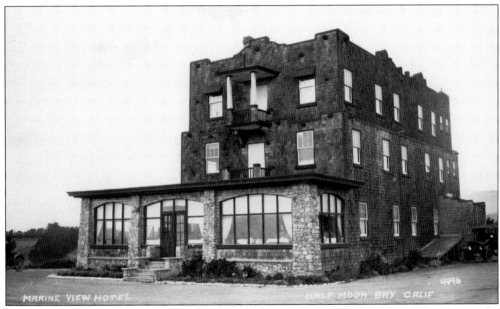

Before moving to Moss Beach, Billy Grosskurth had worked in vaudeville and live theater; he managed Idora Amusement Park in Oakland. During the early 1900s, his business associates included Farris Hartman and Oliver Morrasco and he was linked with Barry's Roadshow, all names that reflected another era. (Courtesy R. Guy Smith.)

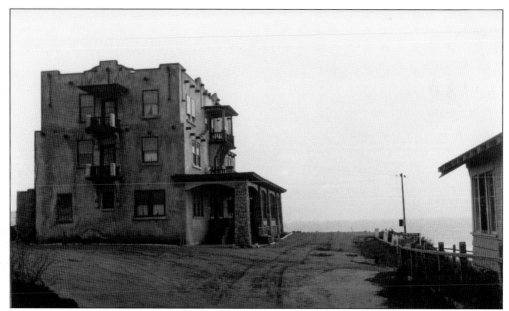

Running a hotel on a wind-swept bluff was completely different than the unpredictable amusement park business, where one of Billy Grosskurth's responsibilities was to make certain that Race through the Clouds, a roller-coaster ride, worked without a hitch. Then there was the stage show to keep an eye on where scantily clad dancing girls performed on a make-believe beach with a famous bear called "Hi." (Courtesy R. Guy Smith.)

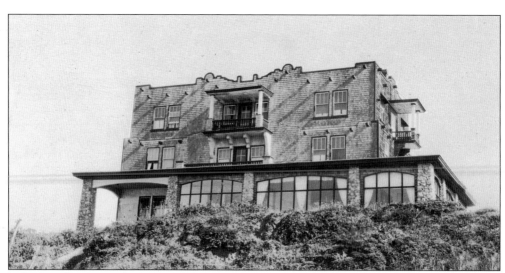

Billy Grosskurth may have moved from Oakland to Moss Beach after he was hit with a series of sticky lawsuits, triggered by injuries suffered by a young woman on the giant slide called Joy Laundry, one of Idora Park's many amusement rides. In comparison to his spiraling legal problems in Oakland, quiet Moss Beach seemed like a dream. (Courtesy R. Guy Smith.)

Working at the amusement park must have put Billy Grosskurth in touch with some eccentric characters. One of them may have been the red-haired millionaire George Whittell. Whittell lived in Woodside, on the peninsula, where he kept a personal zoo of exotic animals, including lions and elephants. Whittell loved custom-made Duesenberg automobiles, which he drove at very high speeds. (Courtesy private collector.)

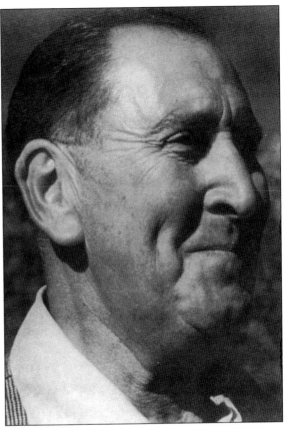

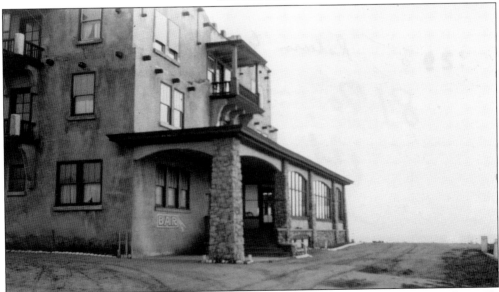

Everybody called the owner of the 20-room Marine View Tavern "Billy" instead of William. He fancied himself a hot piano player, his fingers rolling across the keys during the heady days of Prohibition when the politicians and silent film stars wandered back and forth, drinks in hand, between the tavern and Frank's roadhouse next door. (Courtesy R. Guy Smith.)

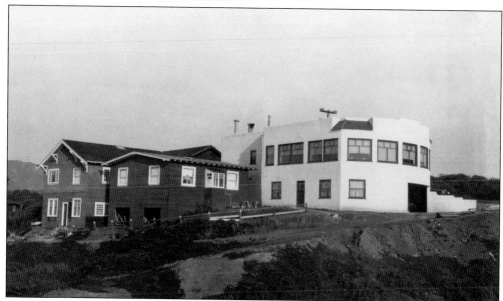

Frank Torres, a native of Peru, worked as a cook at San Francisco restaurants, including the Vesuvius in North Beach, before striking out on his own at Moss Beach in the late 1920s at the peak of Prohibition. Frank's is the white building to the right; the adjacent cottages were available for overnight stays. (Courtesy R. Guy Smith.)

Frank Torres built his Prohibition-style roadhouse—recognized today as an official California State Point of Historic Interest—near a charming bend in the road and overlooking the ever-changing Pacific Ocean. Torres followed in the footsteps of Wienke and Nye, owners of the earliest resorts. (Courtesy R. Guy Smith.)

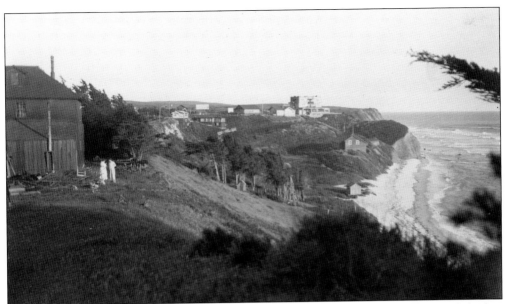

When Frank Torres worked as the ship's cook on a South American voyage, he befriended Alice Lee Longsworth, Pres. Theodore Roosevelt's eldest daughter, a meeting he loved to recount to the patrons at his Moss Beach roadhouse. In this faraway image are both the Marine View Tavern and Frank's, with Grosskurth's taller tavern standing guard over Frank's. (Courtesy R. Guy Smith.)

The final minutes of 1934 were ticking away when eccentric millionaire George Whittell pulled up in front of Billy Grosskurth's Marine View Tavern. Witnesses were stunned at the amazing sight. The elegant Whittell had a lion cub on a leash. It looked as though he was walking his pet dog. (Courtesy R. Guy Smith.)

It is not known what brought George Whittell to Billy Grosskurth's tavern; perhaps it was to celebrate the New Year. Whittell's chauffeur said Billy invited Whittell and his five-month-old pet lion inside. Against everybody's advice, Billy played with the pet that looked more like an adorable kitten than what it really was, when it suddenly mauled poor Billy. He sued for big money but lost the case. (Courtesy R. Guy Smith.)

Billy Grosskurth's Marine View Tavern is gone today, but one can imagine the shingled building in the parking lot next door to the Moss Beach Distillery. By the 1950s, the tavern was decaying, and Billy became a familiar sight on the porch, playing solitaire and reminiscing. After a fire, the hotel was torn down in 1958. Billy died a year later. He was 75. (Courtesy R. Guy Smith.)

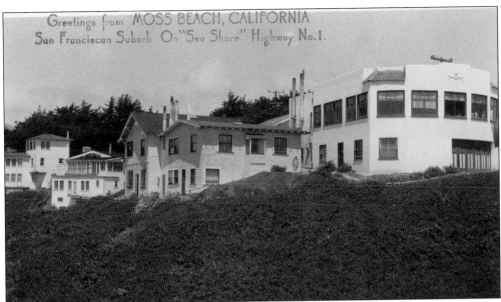

Frank Torres's roadhouse was created in his image. One of the Peruvian entrepreneur's ideas, uncompleted, was to transform the bar into a bullring. There are three stained-glass pieces: *Wine*, *Women*, and *Song*, created by San Francisco artist Otto Dressler for Frank's son Vic, who took over operations of the business. Like Charlie Nye, Frank Torres denied any involvement in the happenings during Prohibition, but in the late 1920s, his roadhouse was popular with the crème de la crème. (Courtesy R. Guy Smith.)

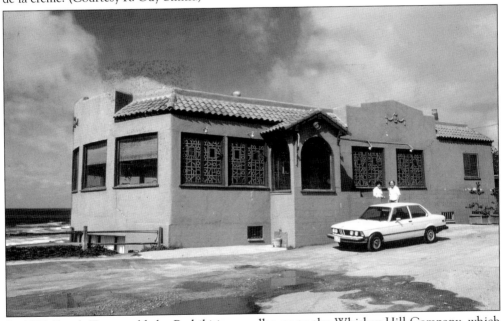

In 1977, Frank Torres sold the Prohibition roadhouse to the Whiskey Hill Company, which was comprised of four young guys whose intention it was to preserve the landmark—to create a reinforced concrete block structure, make money serving tourists, and keep it a comfortable venue for the locals. A tall order, but they did it. The new owners were Sam Varela, Dave Andrews, Paul Young, and Rudy Heredia. (Courtesy Jerry Koontz.)

The new owners changed the name from Frank's to the Moss Beach Distillery. Now they needed an authentic still to back up the new name. Enter Half Moon Bay musician Fayden Holmboe, who had an old still for sale and in perfect condition. The new owners bought it, and it was on display for quite a while before mysteriously vanishing. (Courtesy Joni Keim.)

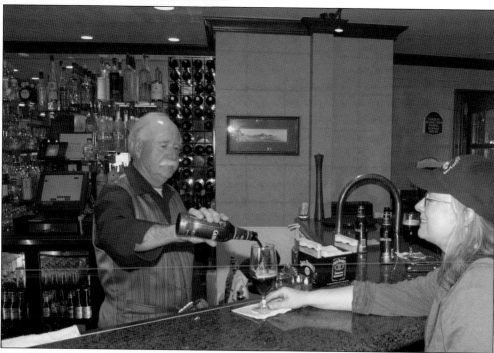

Pete Walters bartended at the historic Moss Beach Distillery for 18 years. The fact that Pete, a familiar face and a member of the close-knit community, was working most nights added to the warmth that the Whiskey Hill owners sought to cultivate—and which they did successfully. In this photograph, Pete bartends at the new Oceana Hotel in Princeton-by-the-Sea. (Courtesy Deb Wong.)

In 1990, the Whiskey Hill group sold the distillery to businessman John Barbour and his wife, Kyoko. The Whiskey Hill owners added a new element to the publicity mix, "the Blue Lady," a sexy ghost from the Prohibition era who haunted the roadhouse. When the Barbours took over, the Blue Lady legend became more significant as well-known psychic clairvoyant Sylvia Browne held séances there. (Courtesy Deb Wong.)

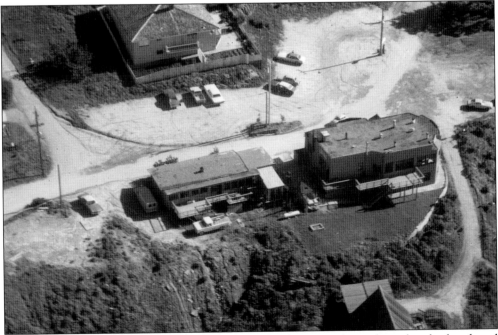

The story goes that there was a love triangle between the piano player, the jealous husband, and the Blue Lady. There was a fight, and the Blue Lady was found murdered on the beach below. Now a ghost, she returns to the distillery, where witnesses say she is active at night, moving chairs and slamming doors. (Courtesy Jerry Koontz.)

For many years, renowned San Francisco Bay Area psychic clairvoyant Sylvia Browne came to the Moss Beach Distillery, along with her fans anxious to be with her at every appearance. The gifted Browne kept guests enthralled as she led séances to bring to "life" the spirit of Mary Ellen Morley, the restaurant-haunting ghost called the Blue Lady. (Courtesy Sylvia Browne Corporation.)

Paranormal investigator and author Sally Richards attended a Sylvia Browne séance event at the Moss Beach Distillery. She says, "When someone asked where the ghost was, Sylvia said he was leaning on my head! She told me he moved, and my headache disappeared. I believe there is something there, but perhaps not what everyone believes." (Photograph by Megan Meadows.)

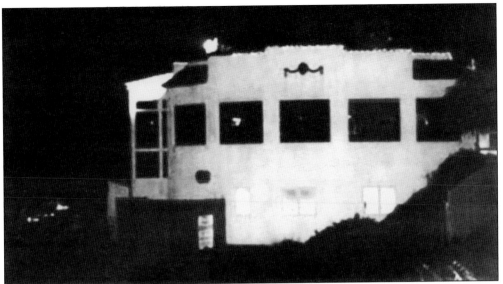

Ghost story author Sally Richards continues, "The incident with Mary Ellen Morley—the Blue Lady Ghost—occurred in 1919. Frank's roadhouse, where Mary Ellen supposedly rendezvoused with John, also believed to be an earthbound spirit there, was built in 1927. Something doesn't mesh but I do believe there is a troubled [apparently misunderstood] spirit at this location." (Photograph by Sally Richards.)

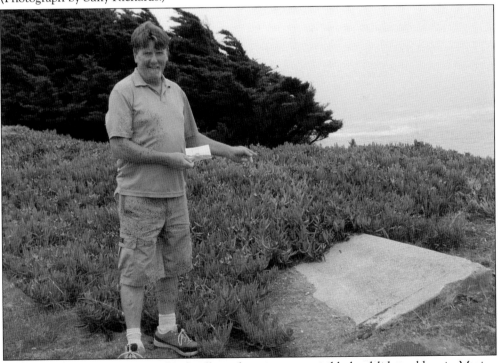

Besides the eerie goings on at the distillery, there is a very visible landslide problem in Marine View. This is not the work of the ghostly Blue Lady, but the natural process called erosion. Home designer Barry McAdoo points at the spot where a home he owned had to be moved away from the cliff to the opposite side of the road. (Courtesy Deb Wong.)

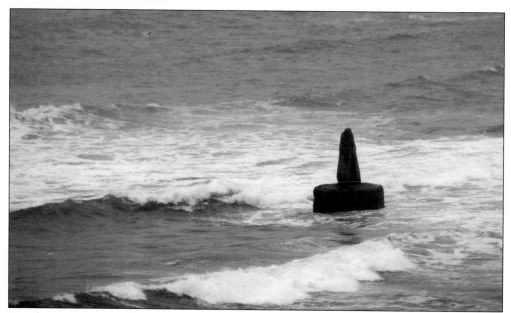

Another mysterious sighting when one is sitting outside on the distillery's patio is the unusual looking concrete object out in the sea. The author wishes it was a statue of Neptune, Roman God of the Sea, but the "thing" is some kind of a marker that was used by the military stationed along the coast during World War II. (Courtesy Deb Wong.)

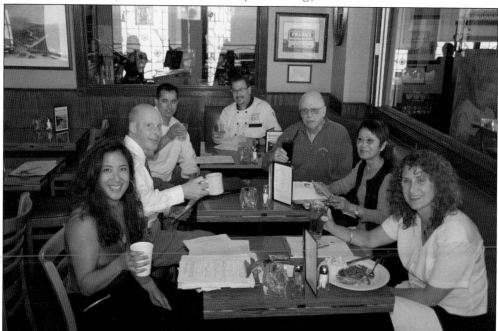

Under the ownership of John Barbour and his wife, Kyoko, the Moss Beach Distillery added a beautiful outdoor seating area, further stabilized the concrete building sitting on a potential landslide area, and received a special California State Point of Historic Interest designation. Restaurant staff pictured are, from left to right, Bev Anolin, John Butler, Santiago Flores, Brian Barisone, John and Kyoko Barbour, and Susan Broderick. (Courtesy Deb Wong.)

Four

R. Guy Smith, the Man Who Said He Could Do Anything

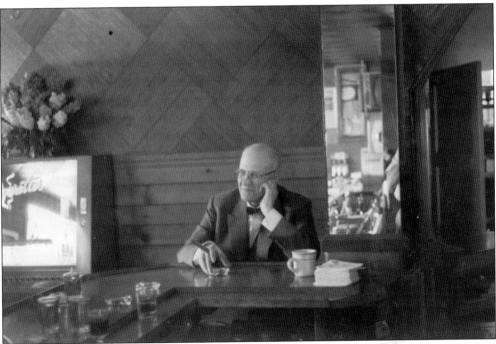

A contemplative moment is pictured here as Raymond Guy Smith enjoys his favorite drink at Dan's Restaurant, owned by the Bortolotti family. Guy came to Moss Beach around 1912 and earned recognition as a talented commercial photographer and master electrician, and he held the powerful position of postmaster for decades. In May 1927, he became the first postmaster to fly to a postmaster's convention. The tiny plane he was traveling in from San Francisco to Los Angeles carried a cargo containing airmail, about an inch thick. Smith's father and grandfather had been postmasters, and he said the family believed in keeping the job in the family. His uncle C. B. Smith was Moss Beach's first postmaster. Guy was also in charge of the telephone office and was a notary public, a deputy sheriff, registrar of elections, and sold insurance and real estate. Local bookstore owner Kevin Magee remembers Guy Smith's famous words, "I can do anything." (Photograph by Donna McClung.)

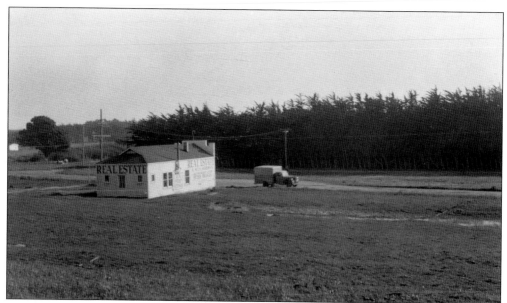

Guy Smith was involved in many ventures, most of them headquartered in this building still standing east of Highway 1. In the 1900s, it was a real estate office. Smith traveled west from Arkansas to help his uncle C. B. Smith sell property. The shutterbug took thousands of publicity photographs of the natural wonders of Moss Beach, a place he came to love so much he never left. (Courtesy R. Guy Smith.)

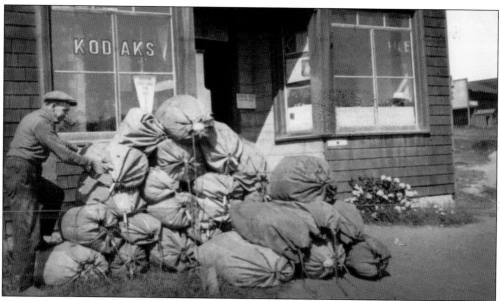

What is inside the canvas bags? Are they sandbags? Or are they filled with hundreds of Kodak prints turned into postcard images showing the natural beauty of Moss Beach? Locals remember Guy Smith using a Kodak box-style camera with an extra-wide angle lens, a novelty at the time. (Courtesy R. Guy Smith.)

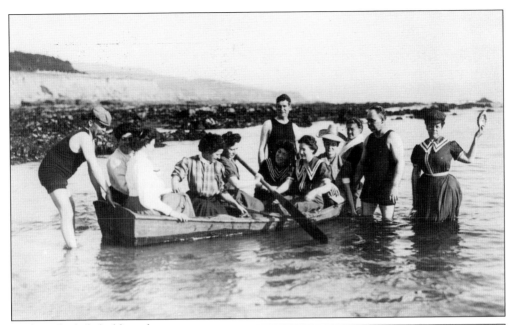

Look at the lady holding the abalone shell. Wearing old-fashioned bathing costumes, these folks rented a boat from Charlie Nye at The Reef's so that they could row near the fragile tide pools. At the time this photograph was taken, abalone were plentiful. Hundreds of copies of this amusing image were turned into photographs and given away to tourists and prospective lot buyers. (Courtesy R. Guy Smith.)

Guy Smith's name appears on yellowed envelopes that came from Henry Kahn's printing facility, The Ocularium. It is an interesting name for a business that was once located across the street from the Palace Hotel in San Francisco. One of Kahn's tips was "Don't expect to get good results from snap shots made before 9 a.m. or after 5 p.m., even if the sun is shining." (Courtesy private collector.)

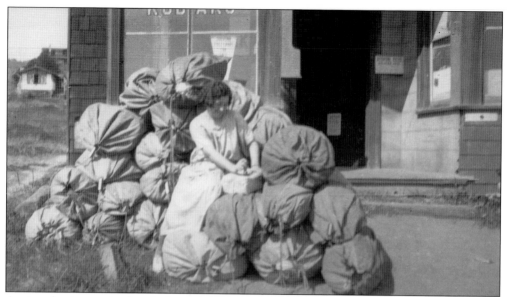

Again, what is contained in the bags? Are there hundreds of postcards of Moss Beach in there? On the window behind the young lady it states, "Kodaks." Not much has been officially documented about Guy Smith's photography work, but the locals recall him taking pictures of every new building that appeared on the landscape. A lot of his images are stunning. (Courtesy R. Guy Smith.)

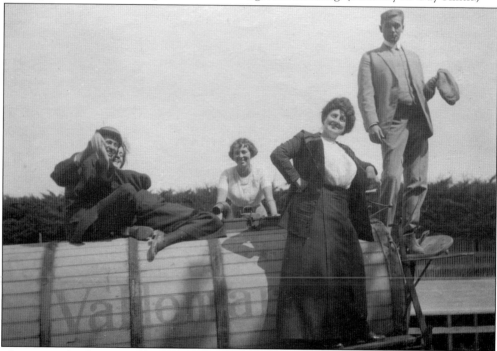

This is a real estate publicity stunt, and these folks are posing with the "Vallemar barrel," the subdivision where there was property for sale. Big barrels like this one were frequently used by the Ocean Shore Railroad to identify the land for sale, a gimmick that was cleverer than a simple "For Sale" sign. There is a street called Vallemar overlooking the Pacific, north of Wienke Way. (Courtesy R. Guy Smith.)

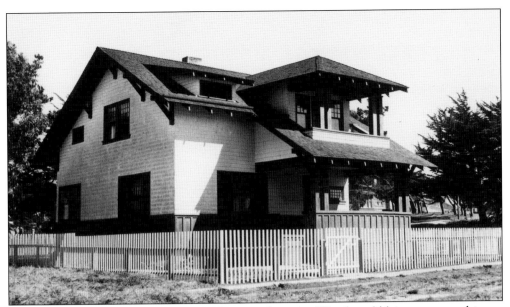

Moss Beach was no longer part of Wienke's seaside resort. Wienke sold his acreage, and it was subdivided into smaller building lots. Guy Smith and his uncle C. B. Smith helped pioneer the successful selling technique of mailing photographs with images of new homes, like this charming one, on them to prospective buyers. (Courtesy R. Guy Smith.)

Looks like a playful Guy Smith sits with a pretty young lady on an unidentified "natural curiosity" on Moss Beach. What is that thing they are sitting on? Guy never married, remaining a lifelong bachelor. And he always dressed well, in a suit and tie, even when visiting the beach. (Courtesy private collector.)

For decades, Guy Smith lived in this beautiful home on the west side of Highway 1, the older section of Moss Beach. His was one of the earliest homes built, and it was kept in immaculate condition. Growing up, Guy worked at many jobs, including in his father's hardware store. He also taught kids at a rural mountain school, was a bank teller, and helped construct automatic electric railway block signals. (Courtesy private collector.)

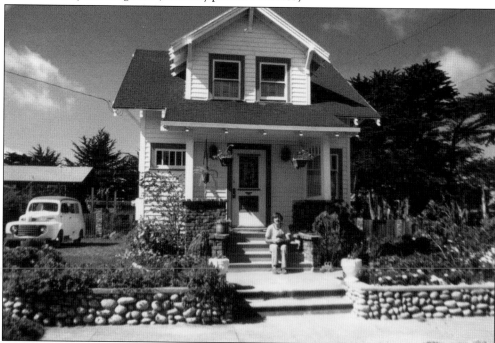

Guy Smith's charming c. 1912 house still stands in Moss Beach, looking even better than it did originally. This photograph was taken in the 1970s, and seated on the steps is the owner, Larry Fosnot, who still lives in the house. There are remarkable coincidences between Smith and Fosnot: both owned similar automobiles and have the electrical business in common. (Courtesy Jerry Koontz.)

Guy Smith's friends and family pose in front of his house. Note the "Guadalupe" sign hanging over the stairs. There has always been an air of mystery about it. What does it mean? Owner Larry Fosnot believes "Guadalupe" may be the name given to the model home he lives in but there was also a huge Guadalupe Rancho on the opposite side of the mountains. (Courtesy R. Guy Smith.)

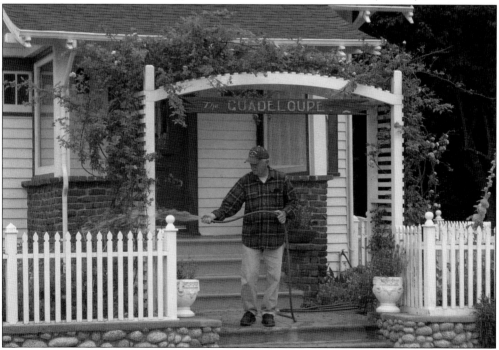

Larry Fosnot, the longtime owner of the Raymond Guy Smith House, waters the flowers in front of the historic home. Could there be a connection between the Guadalupe sign and the sprawling rancho of the same name, which included San Bruno Mountain and was subdivided by well-known peninsula residents in the late 19th century? (Courtesy Deb Wong.)

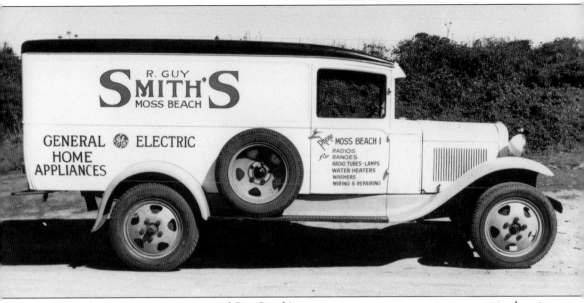

When he was a young man, one of Guy Smith's occupations was constructing automatic electric railway block signals. He had a knack for things electric and as a sideline installed and repaired water heaters, washers, and radios. He specialized in rewiring projects. His work vehicle, seen here, was a familiar sight and in perfect condition, as was everything Guy Smith touched. (Courtesy R. Guy Smith.)

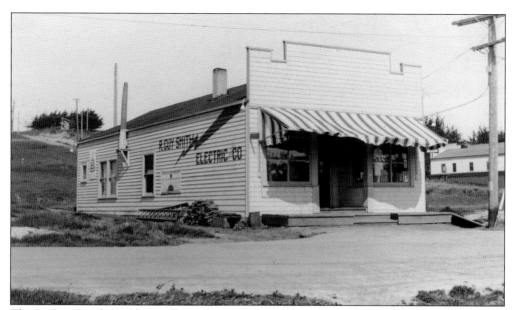

The R. Guy Smith Building still stands east of Highway 1; today San Mateo County attorney Connie Phipps owns it. It has been home to a real estate office and Guy Smith's electric company, headquarters for the *Coastside Comet* newspaper, the site of Moss Beach's post office, and a Kodak film service center. (Courtesy R. Guy Smith.)

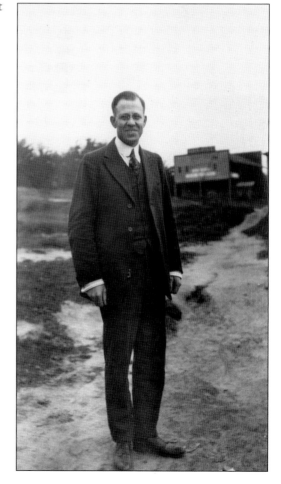

When 36-year-old Guy Smith was appointed assistant Moss Beach postmaster in 1914, he also became manager of the local telephone company, both located in the same building. On that day, farmer John Kyne made the first long-distance call via an old-fashioned switchboard to his famous son, author Peter Kyne. The completion of the call took all day. (Courtesy R. Guy Smith.)

On May 24, 1918, Guy Smith was appointed postmaster of Moss Beach, a powerful position that he held for decades. In 1960, he was named Postmaster of California. His was a family of postmasters, with his grandfather, father, uncle, and an aunt all serving in that capacity. The post office is in the distance to the right. (Courtesy R. Guy Smith.)

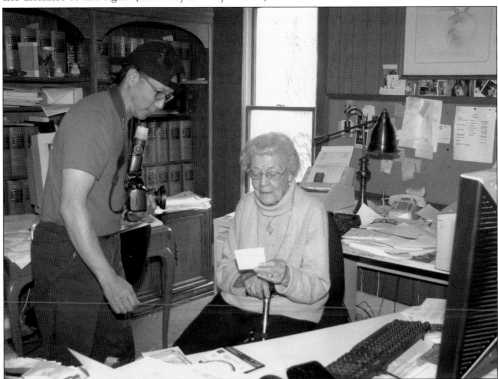

When she graduated from Half Moon Bay High in 1931, Lillian Torre Renard was hired by Guy Smith as his secretary. She stuffed mail into the post office boxes, weighed packages, and sold stamps and money orders. The post office was home to the telephone switchboard; Lillian answered and connected all callers to the rural switchboard. Photographer Michael Wong chats with Lillian, who is now in her 90s. (Courtesy Deb Wong.)

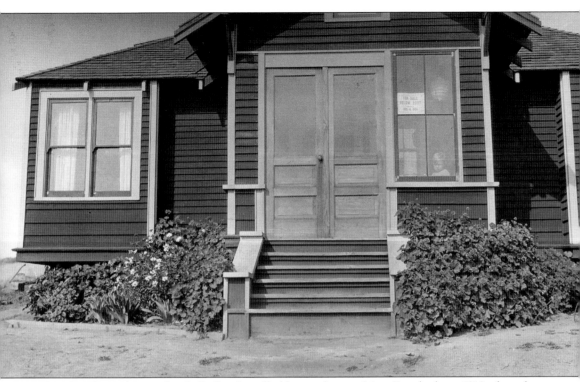

Guy Smith's realtor uncle, C. B. Smith, called his nephew to Moss Beach about 1912 when the Ocean Shore real estate promotional railroad was having a very good year. New hotels and homes were springing up on the secluded coast, including the pretty Moss Beach Grammar School, where the busy Guy soon had himself elected trustee. He had many talents, using his superior skills and "creative eye" as a commercial photographer to shoot pictures of the new homes appearing on the landscape. To publicize Moss Beach real estate for permanent residents as well as summer homes, Smith's images were turned into postcards and sold at the post office. When the fortunes of the Ocean Shore Railroad collapsed, so did the real estate market, with building lots and new homes remaining unsold. During the Depression, property could be purchased for a song, and Guy recorded that era with his camera as well. This home has a sign in the window that reads, "For sale below cost." (Courtesy R. Guy Smith.)

The Golden State Making Ready to Greet You

All aboard postmasters! All on our toes and bound for the National Convention or "bust." This is the opportunity of a lifetime to get together and give the big League a big boost and a shove that will put it over the top with a big bang!

Every one must join the League or admit to himself or herself that he or she is a "bum" postmaster and a "piker," content to follow the old rut and let the other fellow do all the pulling. No one wants to be a "piker." I don't believe there is a piker postmaster in the whole United States. Let's tell the postmasters who do not belong to the League what the League has already done for us and what it may be able to do in the future.

R. GUY SMITH
State President, Moss Beach, Calif.

And just as sure as you are a foot high the League is going to do some more.

The bigger and more closely united it is, the quicker we will do bigger things. Don't wait; let's do it quick and have it over. Then we can get busy on something else.

The coming National Convention at San Francisco promises to be the biggest, best, most enthusiastic and result-getting convention the League has ever held. Yes, this is the opportunity of a lifetime.

Postmasters, when you come to the Pacific Coast, to California, to San Francisco—from the moment you cross the "Great Divide"—you'll find yourself in a new world. The soil is different, the seasons are different, the air is different. You'll never forget your first full deep breath of the pure, sweet, cool, salt sea air as it drifts through the Golden Gate of the West from the Pacific Ocean. The people are different and, yes, you will be different too. You'll never be the same af'er you visit this great new country between the high snow-capped Sierras on the east and the serene, majestic, temperate Pacific Ocean on the West.

You'll go back to your home town with a new thought, a new angle on life. You will be able to tell the folks at home what man, in scarcely more than fifty years, has made out of this vast country merely by his determination to get the things done that he wants done.

San Francisco and California are waiting for you to come. They will be glad to see you and we are arranging to show you as good a time as we can during your spare time from the convention. Let's all be there. Bring the family.

California State League Convention

The annual meeting of the California Branch of the National League of Postmasters will be held in San Francisco the afternoon of September 20. This will be on the last day of the National Convention. Plans have been made for a banquet the same evening at the Fairmont Hotel. This will give all an opportunity to attend the National Convention and the State meeting without additional expense or time. Every postmaster in the United States has been invited to the National Convention and every postmaster in California is invited to attend the State meeting.

Postmasters in the Western States cannot afford to miss this opportunity to attend a National Convention held in our midst. The San Francisco Chronicle predicts an attendance of 2,000. Let's double it. Get in touch with your neighbor postmasters, make up a party and all come along together. Your State President and State Secretary will have headquarters at the Hotel Whitcomb, on Market Street, between 8th and 9th Streets. This is where National Headquarters also will be. We'll all be glad to meet together and get acquainted.

Moss Beach, Calif. R. GUY SMITH, State President.

Reception Committee Appointed

The latter part of July I attended a special meeting of the local postmasters, in San Francisco, for the purpose of arranging for our big National Convention, to be held in San Francisco September 18, 19, and 20.

It was a most enthusiastic meeting and much was accomplished toward making this 1922 convention, one of, if not the biggest and best ever held anywhere. You know the slogan, "San Francisco Knows How," and we are surely going to demonstrate that fact.

I was appointed chairman of the Reception Committee, and wish to state that I have appointed committees to be stationed at the Hotel Whitcomb and the Civic Auditorium, which is in the immediate vicinity of Hotel Whitcomb.

Hotel Whitcomb is to be the official headquarters for the national officers during the convention and satisfactory rates have been secured for all visiting postmasters. All meetings will be held in the Civic Auditorium.

Besides other entertaining features a number of sight-seeing trips have been planned, including a trip through San Francisco's world-renowned Chinatown. The convention will close with a wonderful banquet, to be held at the Fairmont Hotel. Excellent music and several fine speakers have been secured for the occasion.

A word about the weather to be expected. We often have some very warm days during September and advise your coming prepared for it, but above all, be prepared for cool evenings. Being near the ocean, no matter how warm the day is, the evenings are always cool enough for wraps.

All in all, we feel that we will all enjoy a pleasant, as well as profitable, session, and that you will be amply repaid for attending the National Convention in San Francisco in September.

GERTRUDE BRANSON,
Chairman Reception Committee.
Crockett, Calif.

Guy Smith called himself a "master of the post." He was the first postmaster in the world to fly to a postmaster's convention. That was in May 1927, he said, when he flew in a sister ship to Charles Lindbergh's *Spirit of St. Louis* to a state postal convention in Southern California. Postmasters exerted great power, and Guy Smith of Moss Beach was one of them. (Courtesy private collector.)

Guy Smith was a perfectionist. He could account for every stamp sold, and his superiors often praised him for his conscientiousness. Here is a typical letter to Smith, this one from the Burlingame Post Office, "It is a pleasure to receive a report correct. Would like to shake hands with you." (Courtesy private collector.)

United States Post Office

 CLASS

Burlingame, Cal. Nov. 3. 1917.

District Postmaster.

Moss Beach, Cal.

I have received from you this date under register No.59

stamped paper for credit amounting to $180.71.

It is a pleasure to receive a report correct. Would like to

shake hands with you.

J. S. Beard.
Central Accounting Postmaster.

MAYOR'S OFFICE

SAN FRANCISCO

Sept. 7, 1922.

Mr. R. Guy Smith,
Pres., California Nat'l League of Postmasters,
Moss Beach, Cal.

Dear Mr. Smith:

I am in receipt of your letter of
September 5th, confirming your conversation with my
Secretary in regard to my appearing at the opening
session of the National League of Postmasters at the
Auditorium on the morning of Monday, September 18th.

I shall be happy to accept your
invitation to say a few words of welcome on that
occasion.

With my thanks for the honor you do
me and with best wishes for a highly successful
convention, I am

Very sincerely yours,

James Rolph

Mayor.

In 1922, San Francisco's longest-serving Republican mayor, James "Sunny" Rolph, wrote a letter to postmaster Guy Smith confirming that he would speak at the important opening session of the National League of Postmasters. By this time, Guy Smith was an active member of the Republican Party, and he was listed in *Who's Who in California*. By 1922, the Ocean Shore Railroad was turning into a dim memory. Two years earlier, operation of the railroad stopped when employees went on strike demanding higher wages. Competition from the automobile had already cut into the profits of the company, and in response to the strike the Ocean Shore Railroad filed an application with the Railroad Commission to permit abandonment. All operations ceased. Guy Smith, acutely aware of transportation needs on the coastside, immersed his vast energies in developing better local roads for motor vehicles with rubber tires. (Courtesy private collector.)

Guy Smith's uncle, C. B. Smith, became Moss Beach's first postmaster, appointed in 1910 when the Ocean Shore Railroad was carrying passengers from San Francisco to the coastside. Annie G. Smith was appointed postmistress three years later in 1913. Five years later, Guy Smith became the head "stamp shooter," holding the prestigious position until 1958. Guy was known as the "busiest postmaster," and among his many and varied interests he became a leading force behind the Coastside Civic Union, a committee that worked to improve the Ocean Shore Highway and to privatize the Half Moon Bay Airport. One of his goals was to make Moss Beach a seat of power on the San Mateo County coastside. In 1970, when Raymond Guy Smith learned that he had terminal cancer, he took his own life. As a reminder of his legacy, both his home and office, the site of the early post office, still stand. (Courtesy private collector.)

Five

O BIONDA
(HELLO, LITTLE BLONDE)

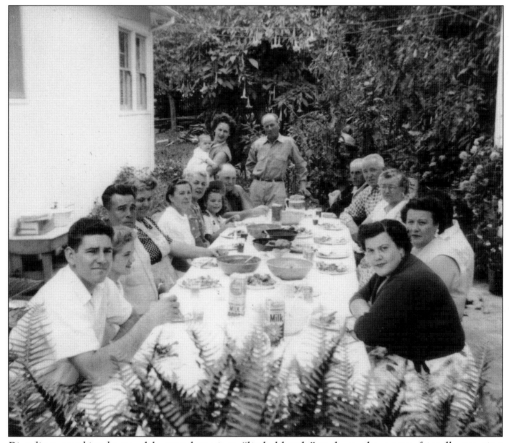

Biondina, or *o bionda*, roughly translates into "little blonde" and was the warm, friendly greeting young girls and women could expect from their male Italian friends and family members in old Moss Beach. When Elaine Martini Teixeira's cousin walked into her family's grocery store at the corner of Etheldore Street and Sunshine Valley Road, he would greet her with, "o bionda." In the 1950s, the Sunshine Valley backyard of early settler Ottavio Torre was the scene of this scrumptious barbecue. Pictured are members of the Ottavio Torre family, spouses, and children. From front to back are (left side of the table) Donald Torre, Sylvia Torre, Tony Teixeira, Lilia Torre, Eva Quilici, Lena Torre Martini, Shelley Bernardo, and Roy Torre; (standing) Gloria Bernardo (holding Kerry Bernardo) and Albert Quilici; (right side of the table) June Torre, Pia Torre, Loretta Martini, Rose Belli, S. Belli, and Tony Torre. (Courtesy Elaine Teixeira.)

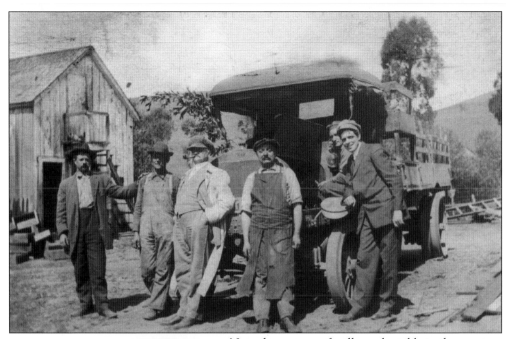

Note the cartons of milk on the table in the previous photograph of the Sunshine Valley barbecue. That milk may have come from the Alves Dairy, but the original members of the Ottavio Torre family, who moved to Moss Beach in the 1900s, raised dairy cows and owned one of the first milk trucks in Moss Beach. Here they are posing at their ranch on Sunshine Valley Road. (Courtesy Elaine Martini Teixeira.)

Cousins Sylvia Belli Parker and Elaine Martini Teixeira love this image of their grandfather, Ottavio Torre. He and his wife, Eugenia, left San Francisco after the 1906 earthquake and moved to Moss Beach where they lived at 1785 Sunshine Valley Road. Ottavio, the Torre family patriarch, was involved in various businesses, including a saloon near an Ocean Shore Railroad barn. (Courtesy Sylvia Belli Parker.)

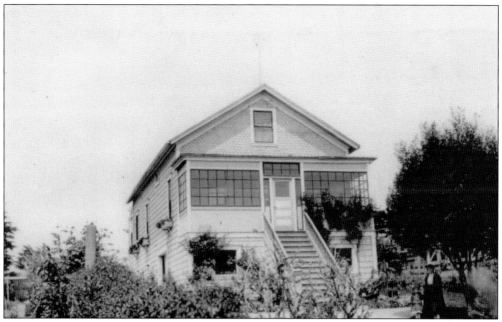

The Ottavio and Eugenia Torre residence was located at 1785 Sunshine Valley Road. Standing in front are Rose (right) and Lillian Torre. In the 1890s, the house served as a one-room schoolhouse with 50 local children in attendance until the new, larger school was built in 1910. Water came from a neighbor's well. The Torre house no longer stands. (Courtesy Sylvia Belli Parker.)

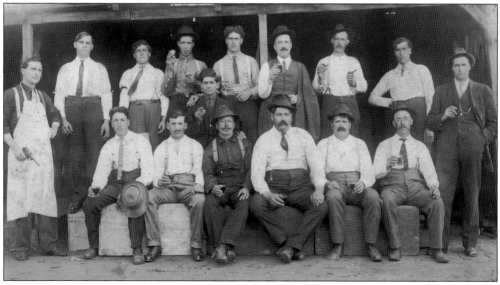

Coastside farmers sponsored young, non-English-speaking men from Europe. After the 1906 earthquake, Sylvia Belli Parker's family moved from San Francisco to Moss Beach. Her grandfather Ottavio Torre coined the name "Sunshine Valley Road" for the connector road linking Montara and Moss Beach. About the gun in the cook's hand, Sylvia Parker explains, "I guess you eat my meal, or else. Ha!" (Courtesy Sylvia Belli Parker.)

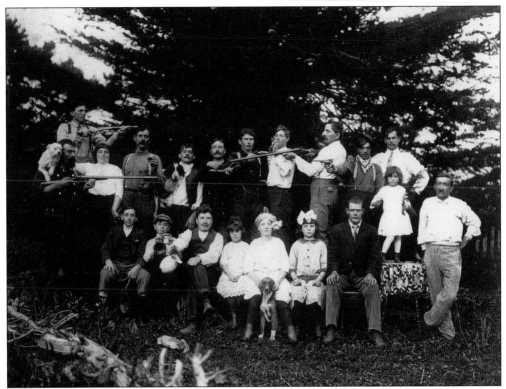

Like the Bellis and the Torres of Moss Beach, the Barsuglias emigrated from Italy to the coastside, where they grew artichokes south of Half Moon Bay. Rifles were used to shoot rabbits that ate crops, and killing them was legal in Moss Beach. Barsuglia relative Gino Mearini was a teenager when he lived in the El Granada Bathhouse during Prohibition, earning good money gathering whiskey-filled gunny bags that rolled up on the beach. (Courtesy Doreen Cvitanovic.)

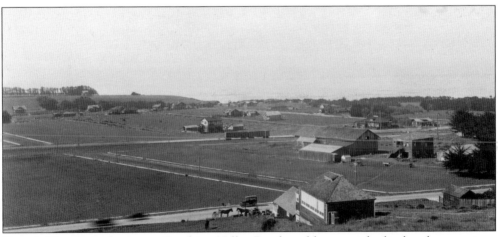

Ottavio Torre raised cows on Sunshine Valley Road, and he opened a lively saloon near an Ocean Shore Railroad barn, where work was performed on the cars. See the horse and carts in the picture? That is where Ottavio's saloon stood. The daughters of the Torre brothers came to the dances and found their future husbands there. (Courtesy R. Guy Smith.)

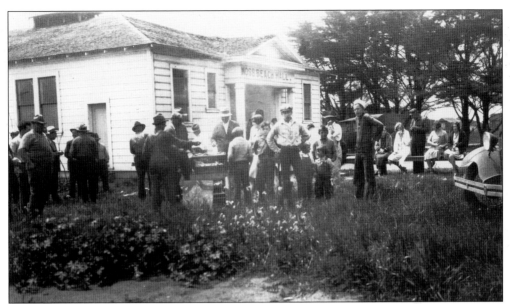

Elaine Martini's father, Angleo Martini, opened a bar in the Moss Beach Hall in the 1930s. He called it The Moss Beach Club. He was busy planting Brussels sprouts in the canyon across from the Half Moon Bay Airport, so his brother tended bar. There were dances and boxing and wrestling matches as well as roller-skating evenings. After World War II, the building was sold to St. Seraphims Hermitage, a retreat for Russian nuns. (Courtesy R. Guy Smith.)

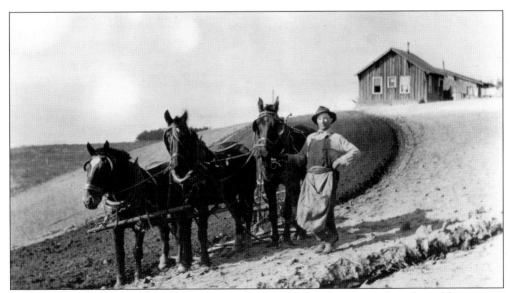

"My mother's father and brothers, along with their father, first settled in the gold country," explains Elaine Teixeira. "My dad and his brothers joined family in Nevada. They all came to San Francisco. My mom's father came to Moss Beach to raise cows after the earthquake." The author discovered that keeping up with how everyone is related to everyone else is very complicated business! (Courtesy R. Guy Smith.)

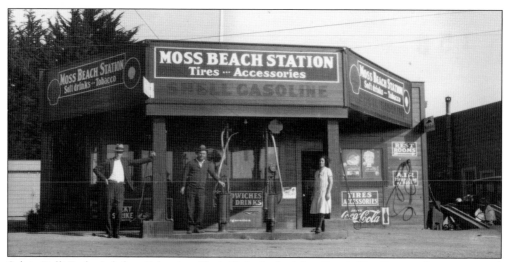

Sylvia Belli Parker's father, Sebastian (far left), built the Moss Beach Gas Station that once stood on the east side of Highway 1 near Sunshine Valley Road. The station was rented out to the other folks in the photograph. Nearby, at the corner, was the grocery store owned by her cousin Elaine's family. (Courtesy R. Guy Smith.)

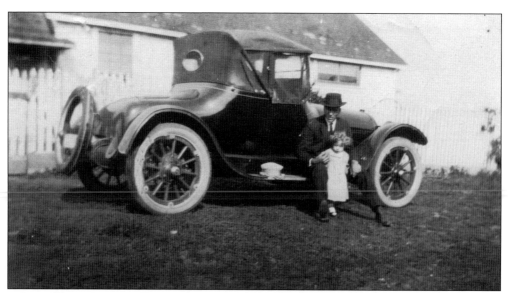

Sylvia Belli was born in 1920, and her parents, who had been living in Moss Beach since 1906, now rented a part of the author Peter B. Kyne's home. Sebastian Belli, seen here with daughter Sylvia, farmed the nearby land. The family soon moved to another house across the street from the grammar school, built about 1910. (Courtesy Sylvia Belli Parker.)

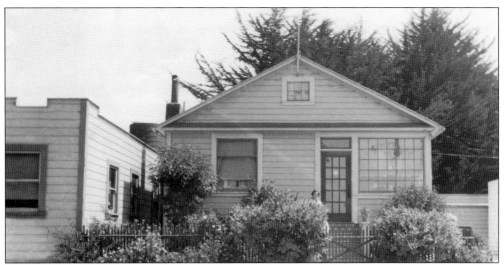

This is the home Sebastian Belli built for his wife and children on Etheldore Street near Sunshine Valley Road. The family home stood across the street from the grammar school and a bocce ball court, a game that originated in Italy. All the members of Sylvia's extended family lived in the neighborhood. (Courtesy Sylvia Belli Parker.)

Pictured is the Belli family home today. In 1932, the Bellis traveled to Italy and stayed with relatives for three months. When they returned, Sebastian built a restaurant and bar in Half Moon Bay called the Half Moon Bay Inn. He leased the inn to a man named Charles Carlini for three years before deciding to run it himself. (Courtesy Sylvia Belli Parker.)

This photograph of the landmark Half Moon Bay Inn was taken early in the morning during the 1970s. Sebastian Belli built the restaurant and bar in the 1930s after he returned from a trip to Italy with his family. Today the Half Moon Bay Inn is home to It's Italia, an upscale restaurant serving delicious pizza. (Courtesy Jerry Koontz.)

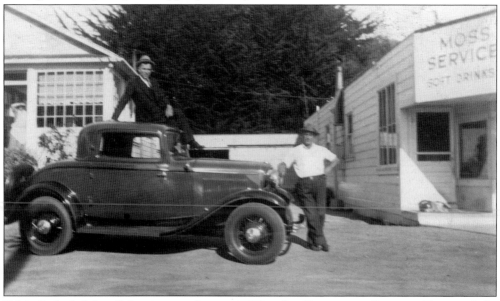

Sylvia Parker's father, Sebastian, was born in 1889 in San Donato near Lucca in Tuscany, Italy. Like the other coastside Italian farmers, he was sponsored and arrived in Moss Beach in 1906; he became a U.S. citizen in 1917. He farmed artichokes and Brussels sprouts on the land near the present-day Half Moon Bay Airport. (Courtesy Sylvia Belli Parker.)

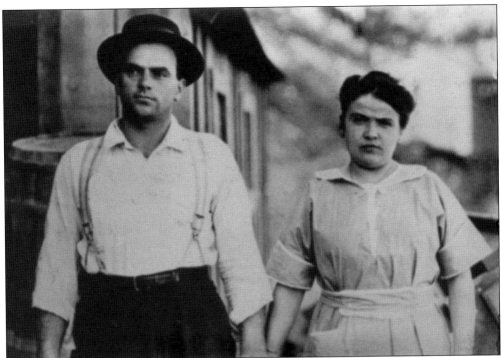

Domenico (Dan) and Domenica Bortolotti came to Moss Beach to open Dan's Restaurant about 1927, leaving behind them an unsuccessful farming venture in Redding. What was to become the beloved Dan's Restaurant had been a boardinghouse, and behind the building was a gas station, presumably the one built by Sebastian Belli. Domenico did not speak English, but he was very successful, the owner of 880 lots. (Courtesy Donna McClung.)

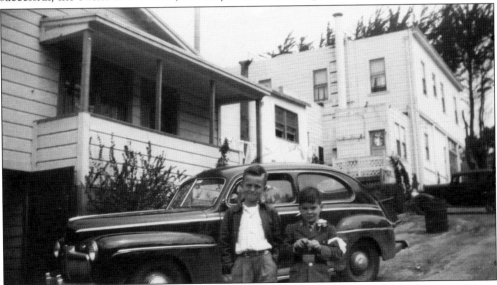

Dan's Restaurant, constructed around 1900, is the two-story building in the background. There were a dozen rooms on the second floor with two shared bathrooms, and it was a perfect place to run a restaurant and raise a family. The Bortolottis owned the entire block except for one lot that belonged to Guy Smith. The younger boy is Richard Bertolacci. (Courtesy Donna McClung.)

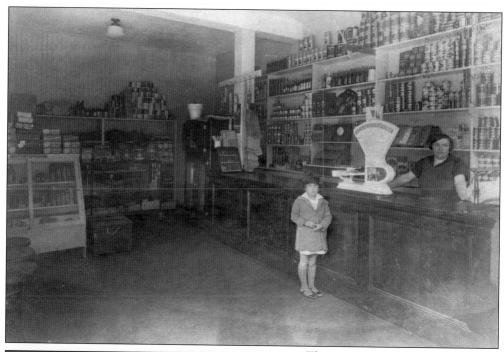

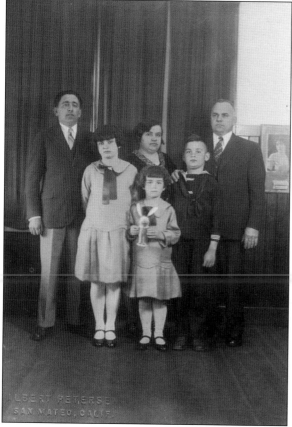

There was a small general store in the left corner of the building where Dan's Restaurant was located. That is Domenica behind the counter with one of her daughters. Later the store became a popular coffee shop frequented by the servicemen who came to train at the Moss Beach military barracks before shipping out overseas. (Courtesy Donna McClung.)

The Bortolotti family poses for a special event. At left is cousin Dominic, who, like Sebastian Belli of the Half Moon Bay Inn (which still stands), opened Dominic's catty-corner to the Half Moon Bay Inn. Today called the San Benito House, it still stands at Mill and Main Streets in Half Moon Bay. (Courtesy Donna McClung.)

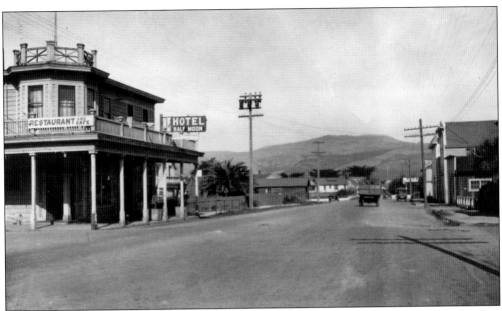

When Dominic Bortolotti opened his restaurant at Mill and Main Streets in Half Moon Bay, the corner location was called the Mosconi House. Dominic's drew a diverse crowd, including boxers who trained on the nearby beaches before enjoying an Italian dinner with fresh artichokes. (Courtesy private collector.)

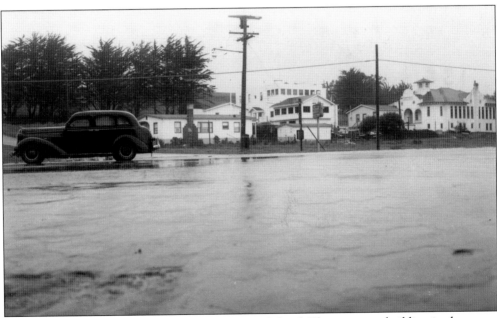

At the far right stands the Moss Beach Grammar School. The two-story building in the center at the back is Dan's Restaurant, later a local culinary landmark with its blue-tinted windows and unforgettable, generous servings of antipasto—a hint of the old Italian lifestyle on the coastside. (Courtesy R. Guy Smith.)

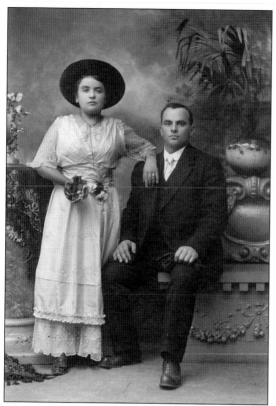

Seen here are Domenico and Domenica Bortolotti in a wedding photograph around 1915. The couple met at Mount Shasta, where Domenico was working in the lumber industry. Domenica worked as a laundress and cook in a boardinghouse. They married and moved to Redding, California, where they operated a turkey farm. The business did not work out for them, and they came to Moss Beach in 1927 to open Dan's Restaurant. (Courtesy Donna McClung.)

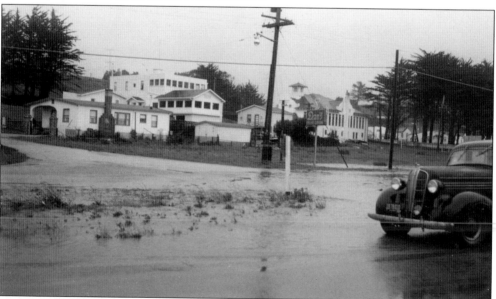

During Prohibition, the coastside was isolated and wide open. Gambling and alcohol were illegal, but locals say there were slot machines in nearby Princeton-by-the-Sea as well as Moss Beach, including one windowless, secret room at Dan's. It seems silly the same restaurants not permitted to sell alcohol in the 1920s can do it openly today and that anybody can gamble in places like Las Vegas. (Courtesy R. Guy Smith.)

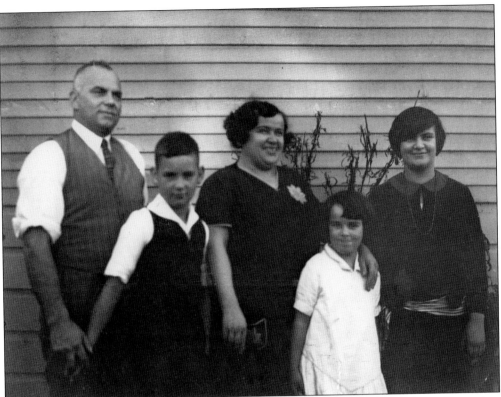

In the early 1930s, the Bortolotti family posed for this photograph. From left to right are Domenico, Barney, Domenica, Lena, and Laura. Barney is Donna McClung's dad, and he met her mom, Josephine Tye, at Dan's, where she was employed. They were an item when Barney went overseas during World War II and later married in 1948. (Courtesy Donna McClung.)

Donna McClung believes Dan's Motel was built in the late 1930s or early 1940s, but the early example of a drive-in motel may have been built a bit later. She says there was talk of moving the restaurant to the motel location, but, of course, it did not happen. Domenico died in a tragic car accident near the Sea Horse Ranch in 1948. (Courtesy R. Guy Smith.)

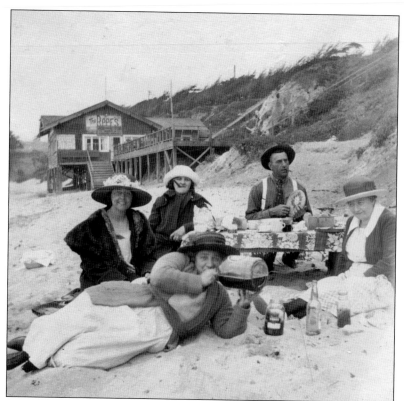

The Belli family enjoys a picnic near The Reef's. The crowds are gone, and they have the marine reserve to themselves. Sylvia Belli recalls "many good times on that beach." In 1944, Sylvia married local man Jack Parker and they had two children; one of them was the well-known San Mateo County journalist Janet Parker who, sadly, died of cancer at 41. (Courtesy Sylvia Belli Parker.)

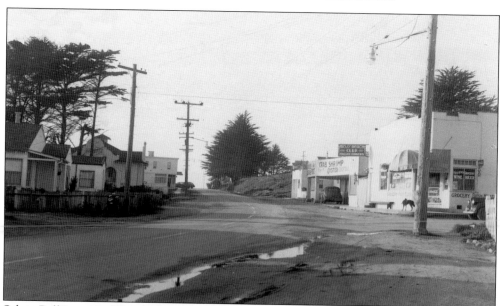

Sylvia Belli's cousin Elaine Martini and her family owned the grocery store at the corner of Sunshine Valley Road and Etheldore Street. When they were kids, they attended Moss Beach Grammar School, which was around the corner. "At one time," says Elaine, "I had six cousins going to school with me: David and June Torre, Donald Torre, Albert Bertolucci, Roy Cardellini, and Bob Prouse." (Courtesy R. Guy Smith.)

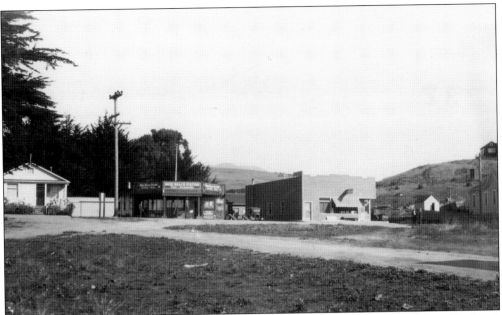

Originally there was no Highway 1; traffic moved along Etheldore Street, which passed by Dan's Restaurant and Elaine Martini Teixeira's family's corner store (seen here). "Beans" Salomone of the Half Moon Bay Bakery delivered bread. Ed and Frank Alves delivered fresh bottled milk from their dairy. (Courtesy R. Guy Smith.)

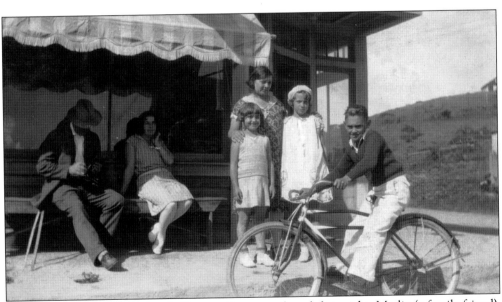

Pictured here at the Moss Beach Grocery Store are, from left to right, Marlia (a family friend), Eva Torre, Rose Torre Belli, Gloria Martini, Sylvia Belli, and Raymond Martini on the bicycle. When Elaine Martini Teixeira was growing up, she worked in the family store, serving the public and stocking the shelves. During the summer months when she was attending school, she and her friends picked peas grown by her relatives in the area. (Courtesy Elaine Martini Teixeira.)

Elaine Martini Teixeira and her brother Raymond Martini visit the old grocery store owned by their parents, Angleo and Lena Torre Martini, at the corner of Etheldore Street and Sunshine Valley Road. Before Angleo died in a 1949 truck accident, the family sold the store as well as many building lots owned by the family. (Courtesy Deb Wong.)

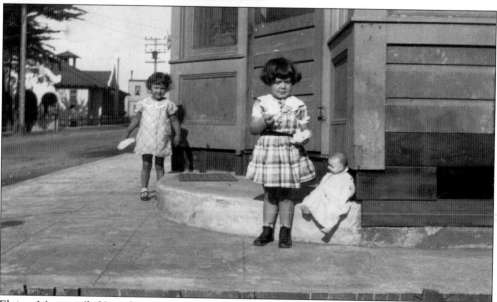

Elaine Martini (left) and June Torre play in front of the Moss Beach Grocery Store. In the background, part of the Moss Beach Grammar School and Dan's Restaurant are visible. Elaine's father, Angleo, owned property across the street, where he raised string beans and potatoes. With a chuckle, Elaine remembers picking both. (Courtesy Elaine Martini Teixeira.)

Elaine Martini stands in front of the bocce ball court. The Moss Beach Hall, owned by her father, Angleo Martini, can be seen in the background. The club was the scene of lively wedding parties and receptions. Eventually it was sold to St. Seraphims Hermitage, a retreat for Russian nuns. (Courtesy Elaine Martini Teixeira.)

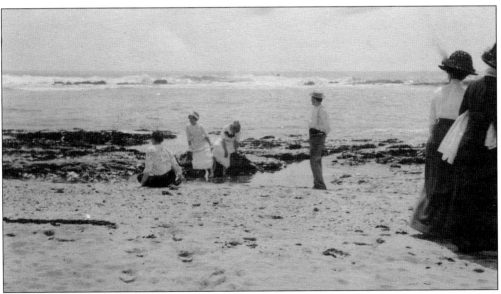

On the east side of the beach town brought to life by the Ocean Shore Railroad were Moss Beach Hall, the saloon, the grocery store, Dan's Restaurant, and Moss Beach Grammar School. On the west side were the Frank Torres's Marine View Hotel and the Marine View Tavern, overlooking the blue-grey waters of the Pacific Ocean. Moss Beach kids knew they were lucky to have the nearby marine reserve as their vast playground. (Courtesy R. Guy Smith.)

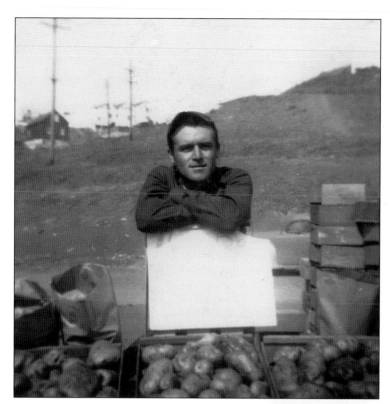

Albert "Muzzi" Bertolucci was related to the Martini and Torre families. He was an artichoke farmer; a cement mason for the Vannucci brothers, who poured concrete for Henry Doelger's houses in Daly City; a bus driver; and he worked at the naval base in Montara. Muzzi's daughter, residential appraiser Sharon Bertolucci, remembers the family's pig farm at the subdivision now called Ember Ridge. (Courtesy Sharon Bertolucci.)

Lillian Torre Renard is Elaine Martini Teixeira's and Sylvia Belli Parker's aunt. When she graduated from high school, she went to work for Guy Smith at the post office and telephone switchboard. There were local lines and party lines. One party line had seven parties on it. If someone used it for too long, an argument would start and someone would end up saying, "Get off the line!" (Courtesy Deb Wong.)

Elaine and Ray Martini lived in Moss Beach when events following the bombing of Pearl Harbor on December 7, 1941, affected them. Elaine recalls, "Government men came to our house. My dad wasn't a U.S. citizen; he was born in Brazil, though of Italian heritage. He came to America in 1913 from Italy. I do not know what these men said exactly but the family was told that my father had spoken well of Mussolini. He neither wrote nor read in English or Italian; he wasn't political. He was a hardworking man raising his family." (Courtesy Deb Wong.)

Elaine Martini Teixeira remembers that G-men searched the family home in 1942. She says they may have been looking for a shortwave radio. They did not find one, but they did find rifles. Elaine's father was a farmer and used a rifle to shoot the rabbits that ate his crops. (Courtesy Deb Wong.)

Finally, Raymond Martini reminded the government men that he had enlisted in the service; he would soon be leaving for the air force base in Blackstone, Virginia. Ray asked the men if they thought his father would send messages to the enemy so they could sink a ship that would be taking his own son to Europe to fight in the war. (Courtesy Elaine Martini Teixeira.)

Elaine Martini and her sisters were isolated in another room when Raymond Martini told the G-men that he was a serviceman fighting for his country during World War II. Upon hearing that, the G-men had nothing more to say. They stopped searching the Martini home and left, never to return. Here is an image of Raymond Martini home on leave. (Courtesy Elaine Martini Teixeira.)

Lillian "Lil" Torre reminisces in the office building that once was home to the post office and local telephone switchboard where she served as operator, fielding calls. Lillian recalls going to work for Guy Smith after graduation from high school. She was happy to get the work; there were not many opportunities during the Depression. Other choices included picking peas or wiring and bunching strawflowers. At the post office, Lillian sorted the mail and made sure the letters and packages got out on the afternoon truck. She soon discovered she was a "jack of all trades." There was a telephone switchboard at one end of the office, and hers was the voice that answered and transferred all calls. The library was represented with shelves of books that could be borrowed. Refrigerators and radios were for also for sale. When a radio did not sell, Guy Smith gave it to Lil as a Christmas present. She says the gift made up for the lack of a commission. (Courtesy Deb Wong.)

Guy Smith was a very busy man who was usually off by himself and did not mix with the old Moss Beach families. As postmaster, he hired Lillian Torre as his secretary and she helped in the post office and with all of his businesses, but the photographer/electrician was always a bit standoffish. According to family lore, Lillian Torre's family worried about Smith asking for their daughter's hand in marriage, but he never proposed to her. Smith did have a good sense of humor, though, as is revealed here where he inserts himself in a World War II–era image. Pictured from left to right are Eva Torre Quilici, Lillian Torre Renard, Gloria Martini, Guy Smith (in a hat), Raymond Martini, Shirley Martini, Loretta Martini, and Elaine Martini. (Courtesy Elaine Martini Teixeira.)

Six

MOSS BEACH PROFILE

During World War II, the coastside and Moss Beach became home to military barracks, a super secret training area for servicemen before they were shipped overseas. After the Japanese attack on Pearl Harbor on December 7, 1941, there was a genuine fear that there could be a similar event, possibly at Pillar Point in Princeton-by-the-Sea, a couple of miles south of Moss Beach. Since the late 19th century, military experts had warned of the vulnerability of that particular stretch of coastline, which was so close to San Francisco. Here a Moss Beach woman looks up at the sky to watch a dirigible, or blimp, passing by, apparently a common sight in the 1940s. (Courtesy R. Guy Smith.)

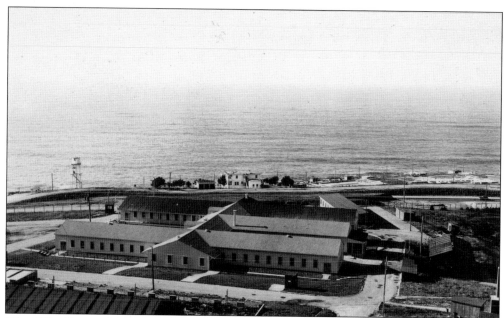

World War II turned the area into a super secret military base. The beaches were off limits except for authorized soldiers and civilians. All Italians and Germans, without U.S. citizenship papers, had to live on the east side of the highway, away from the ocean. The story of what happened to the Japanese has been well documented. (Courtesy R. Guy Smith.)

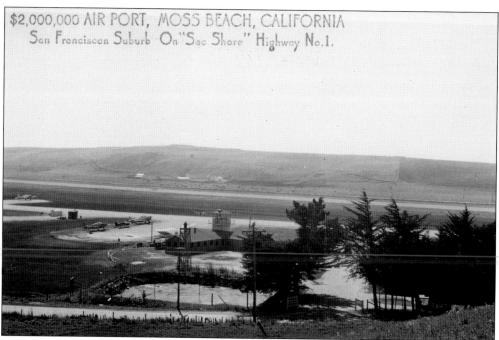

At the Half Moon Bay Airport, members of the Women's Airforce Service Pilots (WASPs) towed targets behind the PQ14s they flew to give antiaircraft gunners practical experience. The coastside was chosen due to its sparse population, where it was less likely that an accident would injure or kill a civilian. (Courtesy R. Guy Smith.)

When compared to the tail of a B29, this is the size of the one-passenger PQ8, similar to the PQ14s flown by members of the WASPs during World War II at the Half Moon Bay Airport. After the unexpected attack on Pearl Harbor in 1941, the Pacific Coast was feared vulnerable to aggression by the Japanese. (Courtesy Shirley Thackara.)

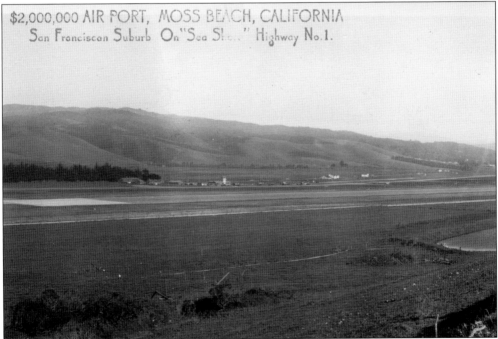

Note that this postcard image of the Half Moon Bay Airport claims its location as Moss Beach, California. It is actually located between Moss Beach and Princeton-by-the-Sea. There was a time after World War II when postmaster Guy Smith and his supporters actively worked to privatize the airport by issuing stock. Today it is known as the Half Moon Bay-San Mateo County Airport. (Courtesy R. Guy Smith.)

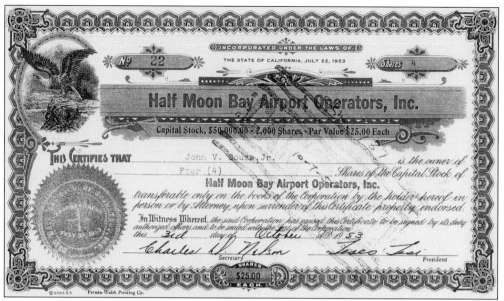

On the post–World War II coastside in the early 1950s, two-thousand shares of stock, available at $25 each, were issued for the Half Moon Bay Operators, Inc. Longtime Moss Beach postmaster Guy Smith had been the secretary-treasurer of the Half Moon Bay Operators, Inc. until San Mateo County took over. (Courtesy private collector.)

World War II pilot Frank Sylvestri had been giving flight lessons on the peninsula at the San Mateo, San Carlos, and Palo Alto Airports when, in the late 1940s, San Mateo County began closing them. Around 1950, Sylvestri was hired to manage the Half Moon Bay Airport, remaining in that position for 29 years. (Courtesy Deb Wong.)

Frank Sylvestri and his son Paul pose outside the West Coast Aviation hangar at the airport. Frank, who passed away in October 2009, could always be found in the hangar, marked with a cartoon of Snoopy on the roof. It was also actually Frank, not Jimmy Stewart, who flew the *Spirit of St. Louis* in scenes filmed near Princeton in the movie of the same name. (Courtesy Deb Wong.)

On any given day, one could find Frank Sylvestri in his office, the hangar with the cartoon of Snoopy on the tin roof. As manager of the Half Moon Bay Airport, Sylvestri made decisions about 727s landing when San Francisco International Airport was closed due to poor weather conditions. Buses would arrive to pick up the passengers and their baggage. (Courtesy Deb Wong.)

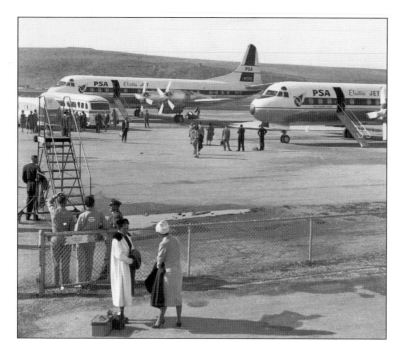

When the weather was bad at the San Francisco International Airport, United, Western, PSA, and Hughes Airlines landed at the Half Moon Bay Airport. One time, in the 1960s, thirty-four planes landed there and it was airport manager Frank Sylvestri who had made that decision. The passengers in this 1957 photograph are waiting for buses to pick them up. (Courtesy Frank Sylvestri.)

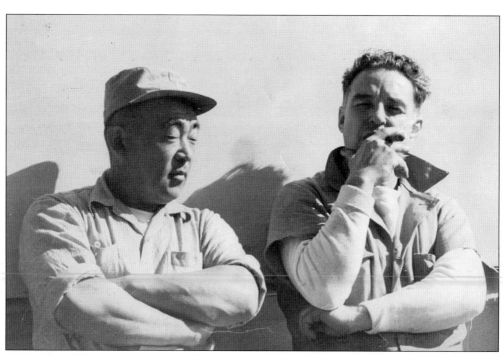

Hamm Sato (left) lived with his family near Frenchman's Creek. After the 1941 Japanese attack on Pearl Harbor, Hamm, a U.S. citizen, was sent to the internment camp at Tanforan and Topaz, Utah. After the war, Sato moved into the canyon across the road from the airport and took flying lessons from Frank Sylvestri. To the right of Hamm is Moss Beach pilot Al Raley. (Courtesy Frank Sylvestri.)

The road that leads to the 3-Zero Café was named Frank Sylvestri Way in honor of the man who managed the airport for nearly three decades. When Frank Sylvestri was hired to manage the Half Moon Bay Airport around 1950, he also gave flight lessons and did some crop dusting. (Courtesy Deb Wong.)

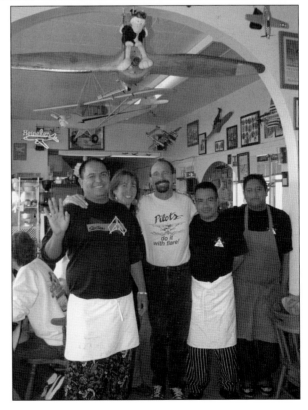

On the wall facing the airport inside the 3-Zero Café is a large plaque that gives the details of Frank Sylvestri's life and career as a World War II pilot. When Sylvestri retired as the manager of the airport, he put all of his energies into West Coast Aviation, located in a hangar steps from the café. Pictured from left to right are 3-Zero employees Cesar, Sharon, Mark, Santiago, and Jaime. (Courtesy Deb Wong)

Today the airport hosts Dream Machines, an exciting spring event featuring the best cars, planes, trucks, and tractors. Do not be surprised if a B-1 bomber or the "Barbarossa," a World War II–era Soviet aircraft, flies overhead. Dream Machines cofounder Bob Senz is seen here with his wife, Barbara, with a friend's Model A behind them. "We hit the car shops," says Senz, "and that's how we started." (Courtesy Deb Wong.)

Bob Senz chats with Skip Walsh, owner of the Model A in the previous photograph. Dream Machines, a popular event that benefits a local nonprofit, quickly claimed a broad audience. One time, a fellow named Archie arrived at the airport with 11 friends and announced, "We came from Australia and we all have cars. Senz credits word of mouth for the success of Dream Machines. (Courtesy Deb Wong.)

Moss Beach was molded in the 19th century, beginning with Mayor Wienke's first seaside hotel. The stories of arriving there by traveling on the Ocean Shore Railroad, at the very edge of the scenic cliffs in some places, have added color to the lore of this community located on the south side of the famous Devil's Slide. (Courtesy R. Guy Smith.)

Dan's Motel, Charlie Nye's hotel, and the Marine View Tavern have vanished from the landscape. In recent times, Karen Brown, author of many bed-and-breakfast books, built the secluded Seal Cove Inn near a forest of trees, and if the trail north is taken one will end up at the marine gardens. The distillery is also nearby. Seal Cove Inn is now part of the Four Sisters Inns' network. (Courtesy Deb Wong.)

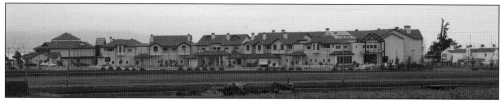

There is a great scenic trail along the cliffs that leads a hiker from Moss Beach to Pillar Point, home of Mavericks, where skyscraper-tall waves draw surfers from all over the world during the winter. There is another trail that leads from Pillar Point to the quaint "cannery row" resort called Princeton-by-the-Sea, where the new Harbor Village complex features the Oceana Hotel and Spa seen here. (Courtesy Deb Wong.)

When businesswoman Peg Smith bought the then 900-square-foot, craftsman-style bungalow in the late 1980s, she found Jurgen Wienke's name on the 1908 deed. Photographs of her home have been published in a book and calendar featuring California craftsman-style bungalows. Peg says Charles Kize made the fireplace in 1931 from local stone at the nearby beach. (Courtesy Deb Wong.)

Many of the early houses built in Moss Beach, like this one, were charming places to live with rock fireplaces fashioned from the granite boulders found on the nearby beach. Developers in the early 1900s believed people would flee San Francisco after the 1906 earthquake and settle in Moss Beach, but transportation to and from the city was always a major problem. (Courtesy R. Guy Smith.)

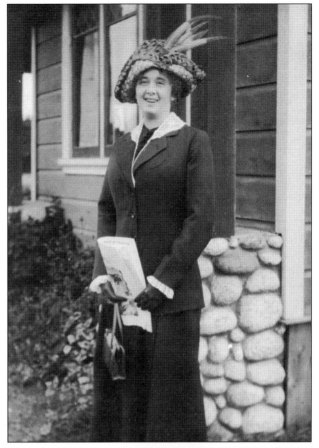

In the 1940s, postmaster Guy Smith saw this interesting reflection in the windows of the grocery store that had been owned by Elaine Martini Teixeira's parents at the corner of Etheldore Street and Sunshine Valley Road. What is visible is the Moss Beach Grammar School that is no longer standing. (Courtesy R. Guy Smith.)

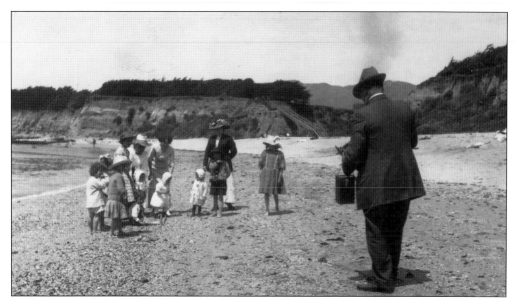

In the 1900s, when The Reef's stood at the north end of the marine reserve, everyone lined up to have their photographs taken at this famous place. When old man Nye was blind and deaf, students came to hear his stories at his place on the cliffs. Decades later, the marine reserve was the playground for the local kids who played on the historic reefs. (Courtesy R. Guy Smith.)

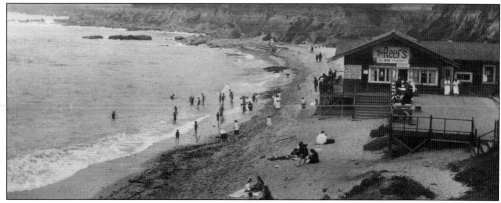

Some locals wonder why the Fitzgerald Marine Reserve was not named after historic figures who had lived in Moss Beach in the early years, including Jurgen Wienke, Charlie Nye, or longtime postmaster Guy Smith. On the other hand, James V. Fitzgerald was a county supervisor from San Bruno who had fished here often and loved the area. (Courtesy R. Guy Smith.)

Bob Breen became the Fitzgerald Marine Reserve's first park naturalist in 1969. Before that he says it was legal to remove anything from the beach, and people did it all the time. He recalls one woman carrying an armful of rocks with extremely rare chitons living on them. She was going to put the rocks in her garden, and when Breen pointed at the living chitons, she told the appalled naturalist that she would scrape them off. By the 1960s, the wonderland that was the reserve had fallen into disarray. Until Breen had authority to stop the removal of sea life, all he could was wave his arms. Near a special place called the "magical forest," there was a spot where dirt bikers practiced what was called "the jump." Breen says the noise was deafening. To put a halt to it, he placed logs in strategic places to keep out the motorcyclists. (Courtesy Deb Wong.)

THE LAST MAFIOSO

by **OVID DEMARIS**

Author of THE GREEN FELT JUNGLE & CAPTIVE CITY

The night Jimmy Fratianno
became a government witness,
not a single Mafia boss slept
(continued on front flap)

In the 1970s, mafioso Jimmy "the Weasel" Fratianno was a frequent guest at Dan's Restaurant. "Just like in the movies, he sat facing the door," remembers Donna McClung, granddaughter of Domenico and Domenica Bortolotti, the original owners of Dan's Restaurant. "He was a tiny, nervous man, weighing not more than 120 pounds. Sometimes he would bring friends. We would always see him at the pay phone at the local market. We suspected he was with the Mafia." Fratianno had been living in a one-story frame house on California Street not far from the Fitzgerald Marine Reserve. Retired park naturalist Bob Breen recalls Fratianno dressed in a tracksuit and smoking a cigar, visiting the marine reserve with a burly bodyguard in tow. He had a book to read, and he never made small talk at the beach. On the other hand, the mobster enjoyed talking with some of the locals, like the owner of the nearby Flying A Station, who was also a deputy sheriff. (Courtesy private collector.)

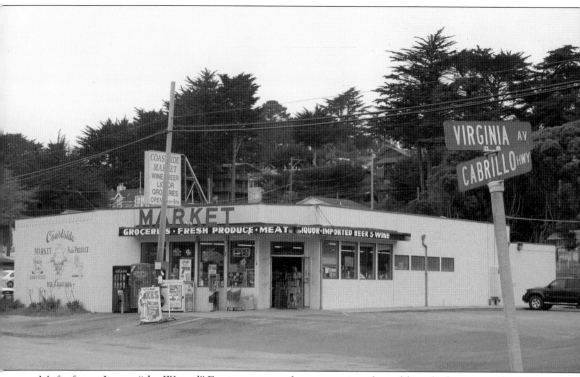

Mafia figure Jimmy "the Weasel" Fratianno was often seen using the public telephone outside this local market. In December 1977, many who lived in Moss Beach were shocked to learn that the FBI arrested the mobster in San Francisco, charging "the Weasel" with two Ohio gangland killings. Agents said Fratianno was "an arranger in the murder of two men in the Cleveland area." One victim was identified as John Nardi, a Cosa Nostra member from Cleveland; the other as Danny Greene, head of the "Irish mob." Fratianno denied participation. "I wasn't an actual participant in whatever happened," he told reporters. "I wasn't even there. I understand there is word I talked to someone. I can prove I was not there at the time." Jimmy "the Weasel" Fratianno entered the Witness Protection Program, the highest-ranking mafioso to do so. (Courtesy Deb Wong.)

In the 1900s, Jurgen Wienke sold a striking acreage, marked by a forest overlooking the crashing surf, to Arthur Smith, a doctor of divinity from Oakland. Today locals call it "the magical forest." After World War II, it was sold to developer Henry Doelger, who built a small weekend home there. The house later burned; the foundation and two palm trees are all that remain. (Courtesy private collector.)

In the 1950s, San Francisco restaurateur Frank "Skipper" Kent bought a small house overlooking the northern edge of the marine reserve and turned it into a showplace, adding two wings, one a studio for his artist wife Lucille's paintings. The Kents moved from Walnut Creek, where they owned a beautiful home with magnificent gardens and an attic filled with curiosities collected from around the world. (Courtesy Frank "Skipper" Kent.)

World-famous magician Channing Pollock and his wife, Corri, purchased the Skipper Kent home in the 1970s. Magicians sought advice from Pollock, a master who raised magic to a new level by ignoring the basic elements of vaudeville—the joking around aspect. Channing's silence during his seven-minute act—he made doves vanish—matched the perfection of the formal attire he chose to wear. (Courtesy private collector.)

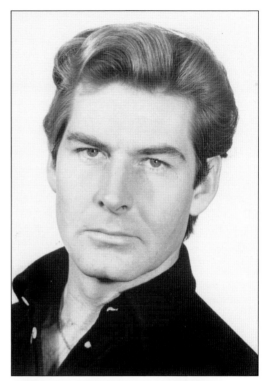

Magician Channing Pollock resided in Moss Beach, but he and his wife, Corri, also owned the Worm Ranch at San Gregorio, south of Half Moon Bay. There they raised earthworms for sale in the retail market, sold to enrich garden soil. In the 1970s, the Worm Ranch's product was featured at Bill Graham's Flower Show at the Cow Palace in San Francisco. The image shows Mark and Flower (a gorgeous couple often asked to model for the Pollacks who were used for an ad to promote the earthworm ranch) harnessing the power of the earthworm. (Courtesy private collector.)

During the Depression, Charlie Coletti purchased many of the lots for sale in Moss Beach. Locals recall him driving to the area in an old Lincoln. It has been said that some of the lots were going for as low as $50. Guy Smith, whose relatives had been involved in selling real estate, produced a series of houses for sale below cost. (Courtesy R. Guy Smith.)

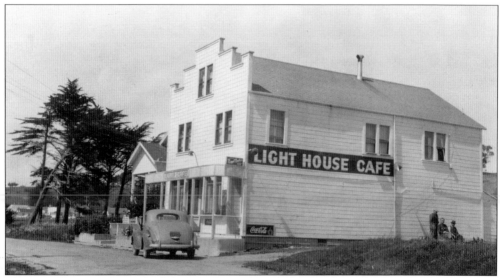

The Lighthouse Café was built by Charlie Coletti and opened as a bar/restaurant during the Depression. In the 1960s, Ruth and Emory Metcalf owned the business. Ruth cooked for her family, charging $3 or $4 to anyone who wanted to join them, usually carpenters. Ruth kept up a correspondence with singer Joni Mitchell, who surprised everyone when she dropped by the café one day. (Courtesy R. Guy Smith.)

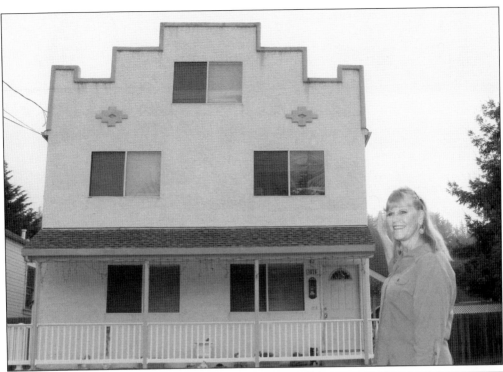

Sharon Bertolucci poses in front of the historic Lighthouse Café. Her father, Albert "Muzzy" Bertolucci, was born and raised in Moss Beach. He attended the grammar school across from Dan's Restaurant and was a volunteer fireman. At one time, the abalone were so plentiful that her father gathered them off the rocks at Wienke Way Beach. (Courtesy Deb Wong.)

There may have been a time when abalone were so plentiful they could be picked off the rocks at Wienke Way Beach, but they are not so easy to find today. Famous local fisherman Tom Monaghan used to dive for abalone, but today he is the distributor (goldengateabalone. com) for the ocean-grown "emeralds of the sea" from Australia. (Courtesy Deb Wong.)

Directly across from the Half Moon Bay Airport, Cabrillo Farms' David Lea leases 210 acres from the Peninsula Open Space Trust. This is a stunning piece of land bordered by Denniston and San Vincente Creeks. In the past, the land has produced flowers and vegetables, mostly Brussels sprouts, bell beans, English peas, and artichokes. Half of the vegetables are frozen for the Green Giant brand, and the remainder is harvested and purchased by Safeway and the smaller chain stores in San Francisco. Packing is done on the property that the Lea family has farmed since 1960. Bruno Guido and Lea's father, Giorgio, who came from Genoa, Italy, to Half Moon Bay in the 1920s, started Cabrillo Farms. The Farmer's Daughter, a produce stand that sells the fresh produce grown on the land, is owned and operated by Lynda Santini (at right), seen here with her cousin Ali Adams. Lynda has owned it since 1981. (Courtesy Deb Wong.)

Today Ashok Thakur manages the Chevron station that used to be the Flying A Station when Joe Miles owned it in the 1950s. Miles was the first full-time fire chief of the Point Montara station. Daughter Lynne occasionally pumped gas at the station and first met her future husband, Half Moon Bay bookstore owner Kevin Magee, while doing so. (Courtesy Deb Wong.)

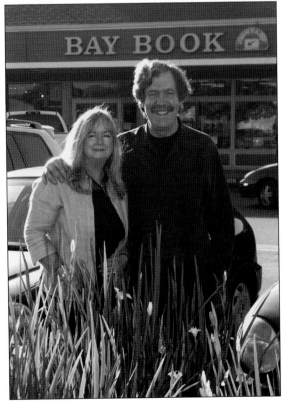

Longtime Moss Beach residents Kevin and Lynne Magee pose in front of their Half Moon Bay bookstore. Like other locals, Lynne remembers Jimmy "the Weasel" Fratianno coming into her dad's gas station to chat. At the time, her father, Joe Miles, was the deputy sheriff. And Lynne, like everybody else, was surprised to learn that "the Weasel" was a member of the mob. (Courtesy Deb Wong.)

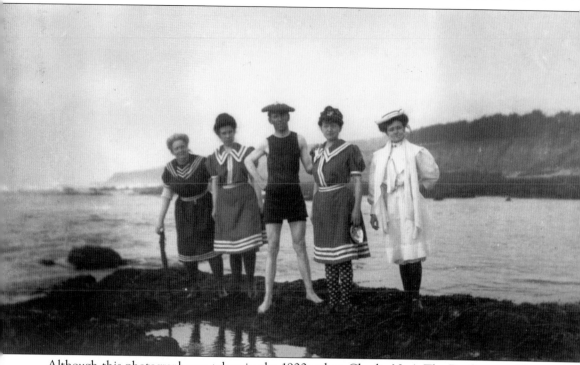

Although this photograph was taken in the 1900s when Charlie Nye's The Reef's was still in operation right there on the beach, the marine reserve remained a playground for generations of Moss Beach children. The kids wandered about on the reefs, exploring nature and swimming in the pools of water. This was their private reserve where they could roam freely, a unique experience denied to city kids. They fished for eel, and abalone and mussels were plentiful. Some locals say that at one time fishermen did not have to dive for abalone. There were so many that they could be pried loose from the rocks. A visit with old Charlie Nye at the Reefs II, with the whale jaw displayed in front of the building, was always a part of the great adventure. In old age, Nye was blind, but he knew where everything was. (Courtesy R. Guy Smith.)

Seven

DEVIL'S SLIDE

This dramatic site where the mountains clash with the Pacific Ocean has served as the backdrop for explorers, the failure of a railroad, and wild shoot-outs during Prohibition. In the late 19th and early 20th centuries, Devil's Slide was the geographical barrier that prevented San Franciscans from moving south to Moss Beach. At one time, Native American guides accompanied tourists across the slide on what must have been a big adventure. Later the Ocean Shore Railroad carved an iron road into the cliffs, but the boulders tumbled carelessly onto the tracks, interfering with the train's schedule. During World War II, locals remember that Devil's Slide was off-limits to all but the military. Gun emplacements for 5-inch guns were built, and radar was mounted on the hillside in the secured zone. The spectacular Devil's Slide slice of Highway 1 opened about 1933, shortly after the repeal of Prohibition. But the "modern roadway" also became captive to the falling rocks, forcing closures and frustrating motorists. (Courtesy R. Guy Smith.)

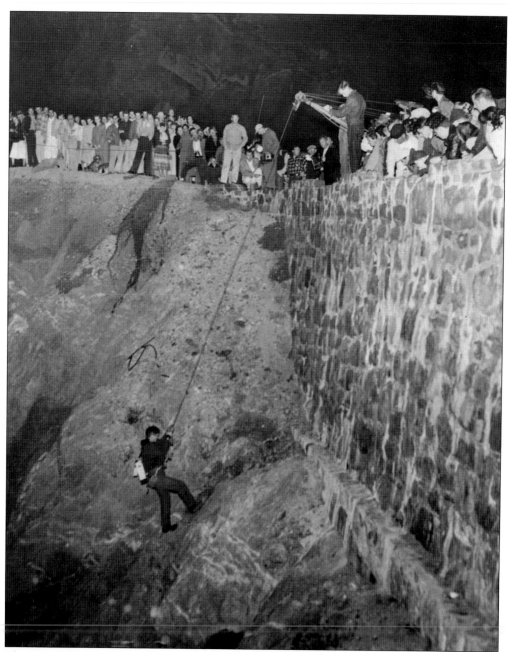

The man dangling on the rope is county sheriff Earl Whitmore, and a daring rescue is in progress in the 1960s on the Devil's Slide stretch of road, a highway otherwise endowed with so many rich vistas it could take one's breath away. Sadly, many people succeeded in ending their lives here, too. In December 1949, an ordinance was passed making it a crime to trespass on Devil's Slide and to park in certain unauthorized areas. The law also sought to bar amateur photographers from tumbling to a certain death down the slide. In the 1960s, many hikers did not pay attention to the official signs warning them about the dangers of climbing on the Pacific Ocean side of the slippery cliffs. With a helicopter hovering outside of the view of this image, sheriff Whitmore begins a successful descent to rescue hikers who have fallen down the cliff. (Courtesy private collector.)

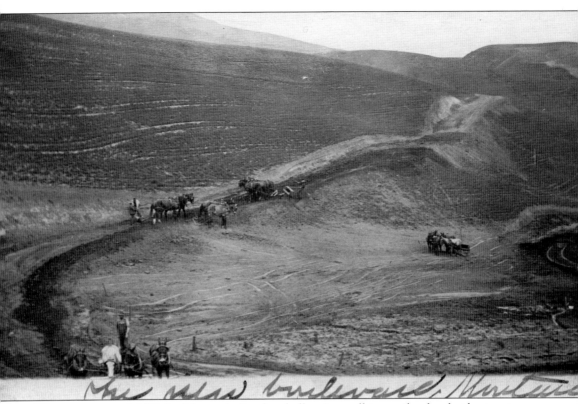

The excavation of old Pedro Mountain Road, a challenging walking trail today that begins at sea level and ends at the highest peaks, is pictured here around 1913. This climb takes hikers up for astounding views of the Pacific and surrounding beautiful landscape. The trail can be picked up at the Montara and Pacifica ends of Highway 1. When completed, the squiggly Pedro Mountain Road wound tightly and steeply to the crest of the mountain. It lies east of the railroad tracks that clung to the cliffs, also offering passengers unparalleled views of the ever-changing sea. During Prohibition, the Pedro Mountain Road became the scene of shoot-outs and hijackings, all over control of illegal whiskey. Steaming, overheated automobiles became a common sight. (Courtesy private collector.)

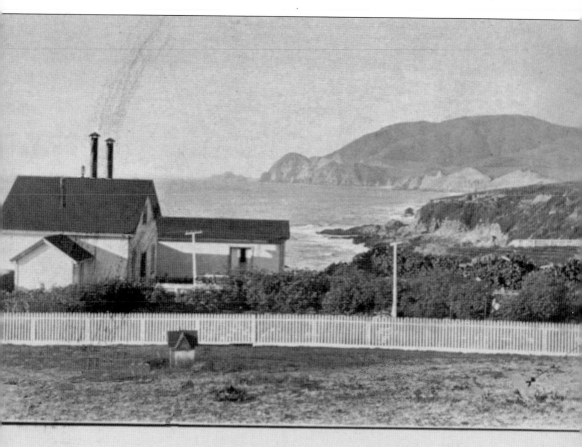

Point San Pedro, near Half Moon Bay

J. Smeaton Chase, the author of *California's Coast Trails*, published in 1913, rode his horse from Mexico to Oregon. As he passed through El Granada, the failed Ocean Shore Railroad resort, he paused to note the "pitiful little cement sidewalks, already bulging and broken." Riding further north he observed that "the road came again to the shore at Montara Point, where there is a small lighthouse. A mile ahead a fine mountain came sharply to the sea, and I could trace a road graded steeply over it. I had not expected another taste of the mountains so near . . . to San Francisco, and I rejoiced at the sight. We soon began the climb, which brought magnificent views of cliff and sea, often several hundred feet almost sheer below." The road Chase wrote of was the old Pedro Mountain Road. The postcard featured here identifies the image as "Point San Pedro, near Half Moon Bay." (Courtesy R. Guy Smith.)

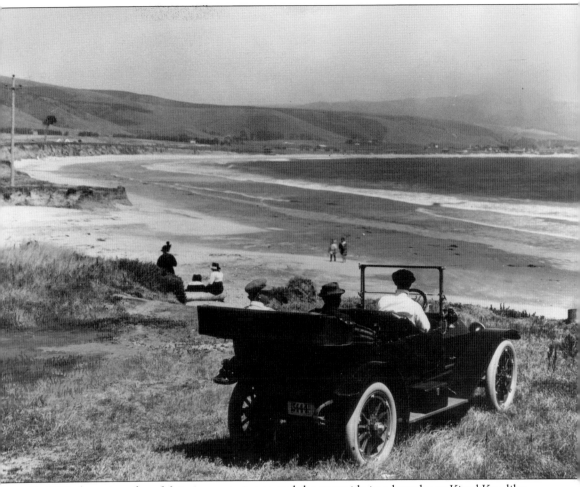

In 1913, the writers from *Motoring* magazine toured the coastside in a brand-new Kissel Kar, like the one seen here parked at El Granada Beach. They humorously commented that the new beach towns were "sleeping again after its invasion by real estate promoters." When the *Motoring* magazine touring party reached Pedro Mountain Road, they issued this warning to their readers: "Even with a thoroughly reliable driver and a trustworthy car, the roads up the San Pedro grade are in such condition and of such a nature that anyone going this way is simply inviting disaster." *Motoring* magazine advised automobilists to turn around and head back to Half Moon Bay, unless, like the Kissel Kar and its occupants, they possessed "strong brakes, a firm hand and a cool head. The big sign which says, 'Dangerous for Automobiles—Take Road Via San Mateo' is one that should be heeded," warned the magazine. (Courtesy California State Library, Sacramento.)

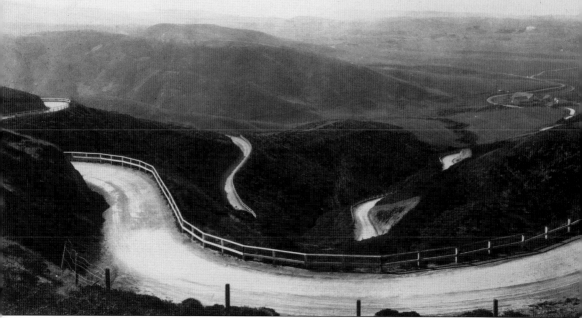

Pedro Mountain Boulevard Elevation 990ft. Moss Bech, Calif.

After their Kissel Kar encountered grades as steep as 25 percent, *Motoring* magazine concluded that the road once used by stagecoach drivers between Colma and the coastside was "as dangerous a ride as any dare-devil driver would venture to take. It is like looping the loop in a motorcar, only there are about 50 loops to negotiate, each one seemingly more difficult than its predecessor. Hair-pin turns, double bow-knots, broken back curves are the lot of the driver over this road, and once down to the bottom, a sigh of relief is generally the only comment of the passenger." It was said that since the Ocean Shore Railroad began running between San Francisco and the end of the line at Tunitas Creek, the road had fallen into disuse. Slides and washouts made motoring uncomfortable. (Courtesy California State Library, Sacramento.)

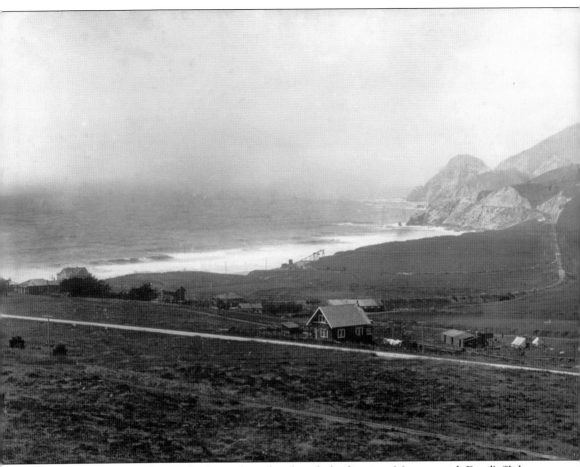

This vintage photograph actually shows the railroad tracks leading into Montara with Devil's Slide in the background. By 1913, the Pedro Mountain Road had been built. Wrote *Motoring* magazine, "At one point the motorist has to make a turn that takes him to the edge of a cliff which towers fully 600 feet above the roaring surf below. The view from here, while it is sublime, is at the same time over-awing, so close does the ribbon-like road run to the edge of the bluffs. From the summit of the San Pedro Mountains, the view is one that would be hard to duplicate anywhere. To the north, west and south, the broad stretches of the mighty Pacific can be seen rolling away in majestic grandeur for miles. Out towards the west, passing steamers on their voyages between the Orient and ports of the coast, look like toy boats on the water." (Courtesy R. Guy Smith.)

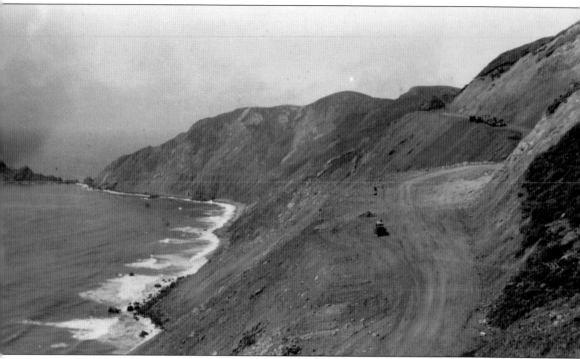

In the 1930s, eight years after the Ocean Shore Railroad gave up on the iron road, the Devil's Slide section of roadway opened following its completion by Joint Highway District 9 (San Francisco, San Mateo, and Santa Cruz). The highway closely followed the abandoned Ocean Shore Railroad right-of-way. Within a year, according to news reports, Devil's Slide began to suffer serious erosion and was closed for repairs after a heavy rainstorm. "Road Closed" signs became a common sight. During the World War II, there was a significant military presence on the coastside. The U.S. government built gun emplacements for 5-inch guns in the Devil's Slide area. There was also an artillery observation point with light-gun emplacements at Grey Whale Cove, named for the California gray whale. (Courtesy R. Guy Smith.)

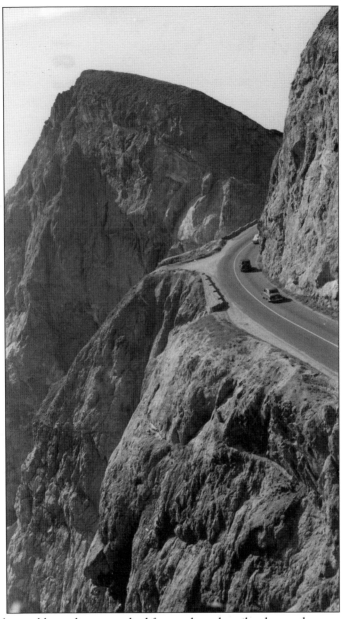

Travel writers the world over have searched for words to describe the raw beauty of Devil's Slide, which evokes the familiarity of a mini Big Sur. In the late 20th century, this savage terrain had defied the dreams of architects who sought to create lavish homesites. But the thrill of this exciting scene high above the crashing surf has drawn the filmmaker's camera to its thorny cliffs. In 1960, an expensive automobile rolled over the edge of notorious Devil's Slide. Tiny sparks of light, the result of friction, flashed as the car gathered momentum, tumbling ever faster to its final resting place several hundred craggy feet below in the Pacific Ocean. Inside lay the lifeless body of an elderly shipping tycoon. Similar disasters had happened many times before on the treacherous cliffside road. Luckily on this occasion, the car and the body were props as a Hollywood film crew shot *Portrait in Black*, a melodrama starring Lana Turner and Anthony Quinn. (Courtesy R. Guy Smith.)

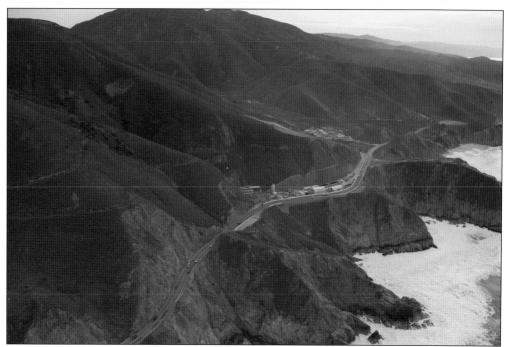

In October 1769, the weary Spanish explorer Gaspar de Portola cast his eyes in the direction of Devil's Slide when he stopped to rest at the beautiful Martini Creek campsite—1 mile north of the Montara Lighthouse on a dirt road east of the highway at the foot of the steep mountains. If Portola, and the 19th- and early-20th-century travel authors, could return to see the geographical barrier Devil's Slide today, they would be amazed at what is happening to bypass the treacherous place that for decades has stymied the free flow of traffic. Caltrans and the Kiewit Corporation have been working to build a 21st-century Devil's Slide Bypass that includes construction of an amazing bridge high in the air at the Pacifica, or northern end of the project, and a tunnel that has been dug through the previously unforgiving mountain near Devil's Slide. (Courtesy Caltrans.)

Getting to Moss Beach in the 1920s was no easy task. "The road coming over Pedro Mountain was terrible, just awful," explained Charlie Nye Jr. "Words can't describe it. It went around turns, and more turns, hairpin turns, short turns, backward turns. There were potholes on top of potholes." The son of Charlie Nye, who owned The Reef's, added that when folks complained about a few little earth slides on Devil's Slide, "Well, that was nothing compared to that old Pedro Mountain Road." He recalled his father talking about even earlier days when travelers arrived by horse and buggy. It then took a full day to ride from San Mateo to Moss Beach. Nye said it could take four to five hours with a horse and buggy to haul lumber from Half Moon Bay to Moss Beach. Charlie Nye Jr.'s father ran the Reefs II until he was so blind that he was forced to stop. That was in 1967. (Courtesy R. Guy Smith.)

EPILOGUE

This is the final book written by June Morrall—author, journalist, documentary producer, and Internet blogger—who passed away in January of 2010. Born and raised in the San Francisco Bay Area, she moved to El Granada, California, when she was still in her 20s, where she lived for the rest of her life. Her main focus for almost 40 years was the history of her beloved coastside, which included Half Moon Bay and surrounding areas. With titles such as *Half Moon Bay Memories: the Coastside's Colorful Past* and *Princeton by the Sea*, June's passion for the history of the coast was clearly evident. Not at all a dry subject for her, she made it a joy for herself and the reader.

June didn't think of herself as a historian, calling herself "just a writer," which belied her active participation with the subject of local history. A board member of several historical museums, including the Spanishtown Historical Society (Half Moon Bay) and the San Mateo County Historical Museum (Redwood City), June definitely qualified as a historian and has been respected as such. But June was more than that.

Part detective, like a modern-day Sherlock Holmes, she used her literary sleuthing skills, as she did when she penned her best-seller *Coburn Mystery*, investigating with a persistence that always brought out new details about a particular place or person. Once that was done, she was like a chef, adding the best ingredients to her subject, with just the right touch of spices to make it fun. And like all good historians, June was a teacher whose lessons were conveyed with the art of a storyteller.

History being what it is, the matter of most import is what a person's legacy is to the world, and it is no different in June's case. This includes her participation with the Internet, including her voluminous online blogs. June's pioneering efforts to bring a digital paradigm to the previously analog coastside history world shows us that the two do not have to be mutually exclusive. June left us far too soon, but she also left us with invaluable contributions to history and communication.

—Deb Wong
February 1, 2010

www.arcadiapublishing.com

Discover books about the town where you grew up, the cities where your friends and families live, the town where your parents met, or even that retirement spot you've been dreaming about. Our Web site provides history lovers with exclusive deals, advanced notification about new titles, e-mail alerts of author events, and much more.

MADE IN THE USA

Arcadia Publishing, the leading local history publisher in the United States, is committed to making history accessible and meaningful through publishing books that celebrate and preserve the heritage of America's people and places. Consistent with our mission to preserve history on a local level, this book was printed in South Carolina on American-made paper and manufactured entirely in the United States.

This book carries the accredited Forest Stewardship Council (FSC) label and is printed on 100 percent FSC-certified paper. Products carrying the FSC label are independently certified to assure consumers that they come from forests that are managed to meet the social, economic, and ecological needs of present and future generations.

FSC
Mixed Sources
Product group from well-managed
forests and other controlled sources

Cert no. SW-COC-001530
www.fsc.org
© 1996 Forest Stewardship Council

Find Your Place in History.